Lives of the Artists

Yayoi Kusama

Robert Shore

Laurence King Publishing

For Hector, Kathleen and Muriel

LAURENCE KING

Published in 2021 by
Laurence King Publishing Ltd
361–373 City Road
London
EC1V 1LR
United Kingdom
T + 44 (0)20 7841 6900
enquiries@laurenceking.com
www.laurenceking.com

A catalogue record for this book is available
from the British Library.

ISBN: 978-1-78627-786-2

Printed in Italy

Laurence King Publishing is committed to ethical
and sustainable production. We are proud participants
in The Book Chain Project®
bookchainproject.com

Cover illustrations © Bodil Jane

CONTENTS

Prologue:
A Summer of Love and Hate

STOCK IS A FRAUD!

George Washington did not look particularly impressed. Was this what the Bill of Rights, proposed and initially ratified on this spot, had been for? Beneath the Founding Father's outstretched hand, four young people were dancing. They were naked. The statue of the first President of the United States of America had witnessed many things in all his years on Wall Street but not that, although had his bronze form been loosed from its pedestal and allowed to roam the streets of Manhattan more freely in the summer of 1968, he might have seen a good deal more human flesh. With the rise of flower power, nudity was becoming a much commoner sight on the streets of New York.

As the dancers gyrated hypnotically to the accompaniment of a conga drummer and climbed on to the pedestal beside Washington, a small woman applied blue paint to their bodies in the form of what looked like polka dots. The woman in question, the 39-year-old Japanese-born artist Yayoi Kusama, knew something about freedom of speech and the First Amendment to the US Constitution. She also knew the value of a good lawyer, which is why she usually chose to be accompanied by hers when she conducted her *Anatomic Explosion* public

performances. The police would be along to stop the fun shortly, she knew, so it was wise to have legal representation.

STOCK MEANS NOTHING TO THE WORKING MAN.

Wall Street was the perfect place for one of Kusama's Happenings: she had been born in 1929, the year of the Great Crash, which had begun here and eventually spread to her Japanese homeland, where the rise of militarism was aided by its aftershocks. And *Anatomic Explosion* was the perfect name for them: her youth had been strongly marked by World War II and its conclusion with the dropping of atomic bombs on the Japanese cities of Hiroshima and Nagasaki. No wonder she was so viscerally opposed to the Vietnam War. 'We want to stop this game. The money made with this stock is enabling the war to continue,' she wrote. 'We protest this cruel, greedy instrument of the war establishment.'

She was planning more events, and in the most public locations – at the Statue of Liberty, in Central Park, in front of the United Nations – and was preparing flyers carrying her message, making an explicit connection between nudism and anti-capitalism: 'Nudism is the one thing that doesn't cost anything,' one read. 'Clothes cost money. Property costs money…Forget yourself and become one with nature!'

STOCK IS A LOT OF CAPITALIST BULLSHIT.

The equation between nudism and the anti-war move-ment was being made in lots of places, even on Broadway, where the success of the musical *Hair* signalled the hippie

counterculture's increasing impact on the US mainstream. But there was one element of Kusama's message that set her apart from her peers: polka dots. The artist had come to be known popularly as the 'Polka Dot Princess' owing to her habit of dressing in polka dots and painting polka dots on the naked bodies of her performers. Today she was wearing a polka-dotted scarf and tights. This was more than a fashion statement; it was political and philosophical too. 'Self-obliteration is the only way out,' she wrote. 'Kusama will cover your body with polka dots.'

OBLITERATE WALL STREET MEN WITH POLKA DOTS.

1

Born to Stars and Bombs

'I was born on highlands. I remember the beautiful stars at night. They were so beautiful that I felt the sky was falling upon me.'

Yayoi Kusama was born in the shadow of Mount Hotaka, deep in the Japanese Alps, on 22 March 1929. Her childhood home would be Matsumoto, a low-lying provincial city in Nagano Prefecture cradled and shielded by the surrounding peaks of the Hida Mountains. The fourth child and second daughter of Kamon and Shigeru Kusama, she was named Yayoi after her birth month, the third in the Japanese lunar calendar. In keeping with local custom, she was a year old when she first saw the light of day.

The Kusamas were a long-established landowning and farming dynasty in the village of Shōnai-mura, renamed Nakajō in the early 20th century and incorporated into the greater Matsumoto City area. Sueo Kusama, Yayoi's grandfather, had been a feted businessman and local politician. He had begun by selling seeds and tobacco, before building up the family business by adding a plant nursery and rising socially to serve – twice – as a member of the Matsumoto municipal assembly.

The only area of life in which Sueo had struggled – hardly a negligible omission in such a strongly patriarchal society

– was in producing a male heir. He and his wife, Yukie, had had their first child, a daughter named Shigeru, in 1905. When no boys were forthcoming in the following years, they did what other Japanese families with fortunes to protect but no male heirs did: they adopted one. So, in 1923, Kamon Okamura took the name of Kusama, married Shigeru, and became the head of the household, if in name only. Male heirs would not be a problem for Kamon and Shigeru, and two were delivered in short order. There would be two daughters too, of whom the second was Yayoi.

The Kusama family business had continued to thrive and now boasted six hothouses as well as large tracts of land. Economic change was on its way, however. 'I was born the year the stock market crashed,' Yayoi Kusama wrote in an early notebook. The Great Crash had struck Wall Street in September 1929 when she was still a babe in arms; its effects rippled around the world and the aftershocks were felt as far afield as rural Japan. Nagano's biggest bank, Shinano, went under in 1930. The economic depression was bad news for farmers everywhere, and Nagano's silk industry would take a serious hit. The Kusamas had to sell off land.

The worldwide financial crisis was accompanied by political upheavals in Japan. The Shōwa era, which began with Emperor Hirohito's ascension to the throne in 1926, would prove a period of intense militarism.

The new regime's Greater East Asia Co-Prosperity Sphere campaign garnered initial popular support by promising to deliver independence to a bloc of Asian territories still under the thumb of Western powers. However, what began as a movement to extirpate colonial influence soon

morphed into an attempt to replace it with Japanese control. Following the Manchurian Incident in 1931, when Japanese forces invaded the Chinese territory, tens of thousands of workers left Nagano to labour in the newly occupied puppet state of Manchukuo. The slogan *hakkō ichiu* ('the whole world under a single roof') summed up the regime's growing imperialist ambitions as, at home, the state began to exercise greater control over all aspects of everyday life.

If the world outside her door seemed to be readying itself for war, Kusama's home life was hardly pacific. 'My mother wielded a tremendous amount of authority and my father was always dispirited,' she remembered. Kamon and Sigeru quarrelled viciously, not least because he was serially unfaithful – his concubines included prostitutes, geishas, a housemaid – and regularly absented himself from the family home. Sigeru, jealous and angry, got her younger daughter to trail him, with the promise of a bowl of wonton soup on her return as a reward.

As a girl, Kusama loved nothing more than heading off into the family's seed-harvesting grounds to sketch the flowers. But she was also, she said, 'a tomboy who loved to climb trees'. In the holidays she might stay with relatives, whom she liked to entertain by dancing naked for them. 'I would sing – to a random melody – lyrics I had written, waving yellow fans and dancing elaborately, without a stitch on.' Word of these performances reached the local boys, who asked her to dance naked for them too, which she did on a straw mat in the garden. 'It was then I realised just how deeply males long for the naked female form,' she noted. When her mother discovered what she had been doing,

she beat Yayoi 'nearly unconscious'. 'When you have four children, one of them can always turn out to be utter trash,' her mother would announce in front of the family's servants.

Though troubled by her father's conduct, Kusama made up her mind that she would go with him if her parents' squabbles turned to divorce. This was partly because Kamon was more sympathetic to his daughter's artistic pursuits: he would buy her materials to draw and paint with. Her mother did not approve of Yayoi's art fixation and actively resisted her daughter's attempts to break free of traditional gender roles in the coming years, repeating a favourite saying that artists were no better than beggars and that the poverty that would inevitably result from pursuing such a career would bring shame upon the family. Kusama later claimed that her mother would kick her palette and they would fight, or she would hit Kusama for 'saying crazy things' and lock her without food in a storehouse for hours on end.

* * * * *

Around the time she turned ten, Yayoi Kusama began to experience hallucinations.

One day as she walked through a garden, violets bearing 'uncanny expressions' started talking to one another. Growing enchanted by her enhanced new vision of the natural world, Kusama engaged in 'spiritual dialogues' with the chattering blooms. At home afterwards, it seemed to her that she was barking rather than speaking. Her suspicions were confirmed when she went into the yard to communicate

with the family pet. 'Sure enough and to my surprise,' she noted in her autobiography, 'I had become a dog.'

On another occasion, as she was staring at a red floral pattern on a tablecloth it began to spread, covering the ceiling, windows and Kusama's own body, and eventually papering over the whole universe. Fearing becoming 'buried in the infinitude of endless time and the absoluteness of space, and be[ing] reduced to nothingness', Kusama fled upstairs. But as she began to mount the steps, they disintegrated under her tread and she hurt her ankle.

At other times a fine silken veil would seem to fall about her, enveloping her senses and causing the people around her to seem to shrink into the distance. No longer able to understand what was being said or even to remember her way home, she might wander aimlessly and take shelter for the night under the eaves of a strange house.

She had never been a particularly happy child: 'I probably already had the sense of despair all around me when I was in my mother's womb,' she reflected. As a young girl she suffered from a hearing defect and asthma 'caused by the tension between me and the outer world'. As such, what happened in that outer world was 'mostly shrouded in mystery' for her. But her hallucinations and experience of 'self-obliteration' and 'depersonalization', as she described these new phenomena, increased her sense of apartness. 'I lost the sense of time, speed and distance, and of how to talk with people,' she remembered. 'I ended up locking myself in a room.'

In her growing isolation, art would be her salvation. As she said, 'Painting pictures seemed to be the only way to

let me survive in this world.' Nets and dots were key motifs in these early works. Repetition, she noted, 'was to become the foundation of my art'.

Indeed, she created work in such volume that the piles of paintings soon reached the ceiling of her room. Images flowed from her mind like lava from an erupting volcano, she said; securing enough canvas and paper to be able to capture them all was a challenge. But whatever the practical difficulties, it was essential to her wellbeing to be able to reproduce visually the 'strange, uncanny things' she saw; such obsessive, repetitive activity allowed her to gain control over, and so free herself from, her visions.

Her father's infidelities resulted in Kusama developing a strong dislike of male sexuality and at the same time – perhaps paradoxically – an obsession with phallic forms. She also said she had happened to witness the sex act when she was small. 'It reached the point where I was assaulted by countless phallic visions,' she recounted. She would sketch flowers in bloom, with the petals forming 'shapes that resembled vaginas'. Dots placed in the middle of them, meanwhile, 'represented penises'. She described hiding in the lavatory to escape her mother when she was on the 'warpath'. There, she felt safe and at liberty to draw 'sheet after sheet' of these sexualized flowers: 'I drew vaginas that had been chewed by dogs and trampled underfoot or penises that were smeared with cat excrement; I called these pieces "Toilet Art".'

She may not have been the only impressionable young Japanese person assailed by such sexualized, and particularly phallic, visions at the time. In 1936, the nation fell prey to the 'Sada Abe panic', after a former geisha erotically

asphyxiated her lover and cut off his penis, which she then carried around for days in her kimono. The story gripped the country. Multiple sightings of Abe were reported as she fled detection; one would-be spotter caused a stampede in the upmarket Ginza shopping district of Tokyo, bringing traffic to a halt. The scandal would serve as the basis for the Franco-Japanese film *In the Realm of the Senses* some decades later. Kusama had clearly not forgotten the incident either when her phallic visions were finding direct expression in the art she made in New York in the 1960s. At that time she would boast that she had produced a far larger set of (fake) male genitals than Sada Abe had managed to collect.

* * * * *

Kusama was a good student, but the political convulsions at home and abroad severely disrupted her school years. 'I couldn't escape this militarism because the government wanted it and the schools wanted it. I suffered. It killed my mind,' she said. The situation deteriorated further after the attack on Pearl Harbor on 7 December 1941 signalled Japan's entry into World War II and Kusama, in company with her classmates at the Matsumoto First Girls' High School, found herself recruited to work in the fields and in the Kureha Textile factory, producing uniforms and parachutes for the Japanese military. The hours were long and the diet poor; articles in the press counselled that insects and straw could be eaten. When the war in Europe came to an end with the German surrender in May 1945, the Pacific theatre became the Allies' main focus. The US

bombing campaign had intensified and Kusama would watch the aeroplanes approaching as they 'flew in broad daylight' over the Japanese mainland. 'I could barely feel my life,' she said.

Her health collapsed. Recuperating from pneumonia at home, she worked on her art. In June 1945, she started a new sketchbook – which had the English word 'Notebook' embossed in the forbidden enemy language in gold on its cover – and gradually filled it with drawings of peonies. Mirroring both her internal state and the blasted landscape beyond the family farm, she depicted the blossoms in the early pages as badly damaged and shrivelled, their leaves eaten away by worms.

An invasion of the Japanese mainland, Operation Downfall, was now being mooted by the Allies and an ultimatum was issued to the Imperial forces in the Potsdam Declaration in July: surrender or face 'prompt and utter destruction'. Emperor Hirohito was unmoved. Since 1942, the Allies had been developing nuclear weapons as part of the Manhattan Project; by the summer of 1945, the first bombs were ready to be dropped.

On 6 August at 8.15 am local time, flying at around 30,000 feet, the B-29 Superfortress bomber *Enola Gay* released the first nuclear bomb over the southern Japanese city of Hiroshima. 'Little Boy' fell for 43 seconds before detonating. Approximately 50,000 Japanese died immediately; the same number again would succumb to burns, radiation sickness and other effects in the coming months. Three days later, on 9 August, a second bomb – 'Fat Man' – was dropped on the city of Nagasaki, with similar results.

Kusama may have listened with her parents as, all across Japan, families gathered around their radios on 15 August to hear Hirohito make a historic announcement. It was the first time a Japanese emperor had addressed the nation in this way. In fact, the speech had been pre-recorded in the Tokyo Imperial Palace a day or two earlier and was broadcast from a phonographic recording. The emperor spoke in classical Japanese, which much of the population did not understand, and anyway avoided saying directly that Japan was surrendering – instead he announced that he had accepted the terms of the Potsdam Declaration. The motives behind the emperor's obfuscation were not far to seek. A significant portion of the Imperial Army considered capitulation dishonourable. Indeed, a detachment had raided the Imperial Palace the previous evening to try to lay hands on the recording and prevent its broadcast. The story runs that it had to be smuggled out of the palace and to the radio station in a laundry basket containing women's underwear.

At the conclusion of the broadcast, to ensure that listeners could be in no doubt about the essential message it had been designed to convey, an announcer said plainly what the emperor would not: Japan was surrendering. The war – the one in the outside world, at any rate – was over.

2

The World beyond
the Mountains

The stars twinkling in the firmament over Matsumoto may have bewitched Kusama's childish senses, but as she grew older the massy Hida Mountains also started to frustrate her desire to discover what else earthbound existence might have to offer. 'I used to wonder what lay beyond those daylight-swallowing mountains,' she remembered. 'Was there just a sheer precipice, and nothing else?'

Cosmopolitan Tokyo and its allures lay 130 miles to the east, but in the coming years the young Kusama would dream of travelling further afield, to Europe and the United States. France would figure in her fantasies of a life lived elsewhere. So would America, obviously enough: the US example was much in evidence in Japan after the war. General Douglas MacArthur, the Supreme Commander of the Allied Powers, had arrived in Tokyo on 30 August 1945 to signal the beginning of the postwar US-operated occupation. In Kusama's imagination, the homeland of this occupying force manifested itself as one of limitless expanses of green meadows and grain fields. She thought she might become a farmer there – given how her family had made its living across many generations, it was unsurprising that

young Yayoi should consider farming as a possible future profession – and paint when her duties on the land afforded her leisure time.

First, though, there was a sojourn in Kyoto, the old Japanese capital that lay 200 miles south of Matsumoto. Following a delay after graduating from high school, in 1948 Kusama persuaded her parents to allow her to leave home to attend the Kyoto Municipal School of Arts and Crafts to study painting. Her mother was displeased but agreed provided Kusama was willing to stay in a house where the very formal Ogasawara etiquette was followed. That way, her time might not be wasted; even as she trained to be an artist, Sigeru's rebellious daughter would be preparing herself for a more conventional destiny. Kusama failed to attend the lessons, however.

Her official goal in coming to Kyoto was to study *Nihonga*, or 'modern Japanese-style painting', and she thoroughly absorbed its techniques and honed her observational skills. But she did not like her teachers, who were too bound up with hierarchy and an insistence on painting with minute precision. As such, she would stay in her room to paint, to the point that the school threatened her with expulsion.

Favoured activities when she went outside included meditating in the rain and trips to the zoo, where she sketched the monkeys with their pink, wrinkly faces. She also painted pumpkins. She had first encountered these characterful plants on a trip to a seed-harvesting ground with her grandfather. When she tried to pluck one, it 'immediately began speaking to me in a most animated manner', she recollected.

In everyday speech, pumpkins figured as metaphors for unattractive human beings, but Kusama found herself 'enchanted by their charming and winsome form' and sketched them fascinatedly. One of her pumpkin pictures had won a prize in a local art competition when she was 17 or 18. Her pumpkin-painting habit now continued in Kyoto. 'Just as Bodhidharma spent ten years facing a stone wall, I spent as much as a month facing a single pumpkin,' she remembered. 'I regretted even having to take time to sleep.' (Legend has it that the great Zen patriarch Bodhidharma spent so long in meditation in front of a wall that his legs atrophied and fell off.)

A quasi-traditional form of Japanese painting developed in the late 19th century in response to Westernization and using mineral pigment with glue on rice paper, *Nihonga* was increasingly seen as politically suspect in avant-garde art circles. The style dated back to the Meiji Restoration in 1868 and the reopening of trade with the wider world, when it was developed to reflect Japan's aspirations to become a Western-style modern nation-state. But the nationalist government had then promoted it over Western-style (usually oil) *yōga* painting during the 1930s as a patriotic style of self-expression: during the war, Kusama's own *yōga* art teacher at school, Matsumoto Noburo, had been replaced by the *Nihonga* specialist Hibino Kakei (né Teruo). In the coming years, the government increasingly influenced the content of art magazines, which favoured *Nihonga* and the classical arts of Japan's military allies Italy and Germany.

Reminiscent of Kusama's 1945 sketchbook with its drawings of damaged and shrivelled peonies, the unearthly,

sunflower-strewn landscape of *Lingering Dream* (1949) is the largest and most substantial of her surviving *Nihonga* works. Displaying a markedly experimental spirit – as Midori Yamamura notes, it 'modernised the traditional Japanese spatial conception of *yohaku*' – it was chosen for display in autumn 1949 in the second exhibition organized by Sōzō Bijutsu, a group of young artists intent on reforming the genre.

Onions, a still life from the previous year, suggests that Kusama was looking carefully at the work of *Nihonga* artists such as Gyoshū Hayami and Kagaku Murayama, blending traditional refined Japanese minimalism with Western realism. Hence, though Kusama would declare her schooling a waste of time, 'this detour…put her in contact with the distinctive hallucinatory vision of these two exemplars of modernist *Nihonga*', as Akira Tatehata has noted. Moreover, with its 'unique juxtaposition of real and unreal' and distorted background grid formations, *Onions* 'unmistakably foreshadows Kusama's later net paintings'.

A year and a half after her departure to study in Kyoto, and following a further period with *Nihonga* master Maeda Seison in Kamakura City, Kusama was back in Matsumoto. The prescriptiveness of *Nihonga* did not suit her. Kusama was a natural and voracious autodidact: she had taken to using the services of translators to make it easier for her to access materials in English and she soaked up insights into avant-garde and Western tendencies from magazines such as *Atelier* and *Mizue*. This sort of material had not been available during the war, of course, and Kusama now gratefully immersed herself in it. Techniques and materials

became her constant study, and she began experimenting with a variety of Western-style approaches. Her progress was fast and her production prolific as works in media including ink, pastel, watercolour, gouache and tempera poured out of her studio. As Tatehata has remarked, 'Linear rendering from nature is the foundation of *Nihonga* training, and this was the only period when Kusama, who since childhood had drawn images based on her own fantasies, would concentrate on naturalistic sketches of the exterior world'. It would serve her well when she next explored 'an autonomous surrealism driven by inner necessity'.

The impact on Kusama's youthful sensibility of the war as well as her wide-ranging art research can be seen in the swirling horror of works such as *Accumulation of the Corpses – Prisoner Surrounded by the Curtain of Depersonalization* (1950). (The subtitle was only added later, after Kusama saw a psychiatrist and she recognized her own symptoms in a description of *rijin-sho*, or 'depersonalization syndrome', in which a 'swirling curtainlike haze' seemed to fall on her perception.) Mixing oil and enamel paint, it is strikingly innovative in its use of materials. The same can be said of *On the Table* (1950), a fragmented, Cubist-influenced image built up using a mixture of sand from the riverbank on the family estate and animal glue. The support was no less unusual in its improvised quality: in place of canvas, the image was painted on a seed sack found on the Kusamas' plant nursery and stretched over a plywood panel.

Kusama was on the cusp of her 23rd birthday when she staged her first solo exhibition. The venue was the First Community Centre in Matsumoto. The show, held on

18–19 March 1952, contained around 270 works, many suggestive of natural forms such as eggs, seeds, trees and flowers, and often microscopic or cosmological in appearance. The work confirmed that Kusama was aware of avant-garde, politically progressive tendencies around her, such as the 'Panreal Manifesto', which had been produced by a radical *Nihonga* group in Kyoto and which called for an 'exhaustive exploration of reality in art'.

A second solo show followed swiftly, running from 31 October to 2 November 1952. This time there were around 280 works – one contemporary newspaper report suggested Kusama was making 50–70 individual pieces a day, and sometimes 100. Her extraordinary rate of production was facilitated by the shift from *Nihonga* to media such as watercolour, which were better suited to faster, more spontaneous mark-making. A number of the works in the exhibition featured repeating dot and net patterns, which would become signature elements of Kusama's work in the coming years.

Kusama's parents were not aligned with her professional ambitions. Traditionally, well-bred young women from the conservative Japanese provinces were not supposed to dream of making art; they were expected to settle down and raise a family of their own. Predictably enough, Kusama's parents showed their daughters a steady stream of portraits of approved prospective mates. Her sister succumbed and married, but Kusama refused to evince any interest in a husband. New attitudes promoted by the Occupation – the 'MacArthur' Constitution, promulgated in 1947, was aimed chiefly at demilitarization and democratization following the profound shock caused by the emperor's announcement

on 1 January 1946 that he was not a god – may have provided crucial support for Kusama as she set about charting a highly individual course for herself.

A sexual revolution was under way. The sight of US servicemen holding hands with their wives and kissing in public sparked a shift in behaviour and attitudes in Japan. Osculation and public displays of affection generally became a symbol of democratization, as did the introduction of Western-style dating. Crucial in the movement towards sexual equality were the articles included in the new Constitution that set about establishing women's rights. As US women's rights advocate Beate Sirota Gordon, who played a crucial role in drafting the Constitution, remarked: 'Japanese women were historically treated like chattel; they were property to be bought and sold on a whim.' Article 24 now stated: 'Marriage shall be based only on the mutual consent of both sexes and it shall be maintained through mutual cooperation with the equal rights of husband and wife as a basis.' In addition: 'With regard to choice of spouse, property rights, inheritance, choice of domicile, divorce and other matters pertaining to marriage and the family, laws shall be enacted from the standpoint of individual dignity and the essential equality of the sexes.'

The new, US-inspired spirit of the age may have helped Kusama resist pressure from her parents to pick a husband. At the same time, if Kamon and Sigeru were unconvinced by her choice of career, following the exhibitions in Matsumoto a number of professional artists and critics were showing a healthy appreciation of the newcomer's work. Nobuya Abe, member of the prestigious Association of Art and Culture,

expressed support, and the well-known critic and surrealist poet Shūzō Takiguchi wrote a text to accompany Kusama's second solo show. 'Her drawings flow unceasingly as if a dam had broken,' he observed. '...Visionary forms of imagery should not be a fabrication but the symbolic appearance of such deep emotion. Here, an artist's breath becomes the natural flow which may be called her handwriting.'

Many commentators have noted a Miró-esque quality about Kusama's mystically suggestive watercolours of this period. Indeed, Surrealist – and perhaps Symbolist – elements were already evident in the 1949 painting *Lingering Dream*. Takiguchi, who had been arrested during the recent war for his association with Surrealism (the French art movement was considered deeply subversive by the totalitarian state), had written the introductory text to a feature in the August 1949 issue of *Atelier* presenting the work of Joan Miró to Japanese readers for the first time. Takiguchi knew Miró personally – not to mention Dalí, Duchamp and other leading Surrealists – and their preoccupations were now percolating through Kusama's work. Not that Kusama was comfortable with the idea of having been directly influenced by Miró or any wider movement, later declaring: 'I had nothing to do with Surrealism.'

Kusama travelled to Tokyo to meet Takiguchi and seems to have been inspired by his words – and his impressive book collection – to begin to try decalcomania. The pair shared a deep and lasting affinity. Decades later, following Kusama's return from New York, Takiguchi would provide an afterword to her 1978 debut as a novelist, *Manhattan Suicide Addict*. It was entitled 'My Nymph through Eternity'.

In a 1955 essay entitled 'Ivan the Fool', Kusama wrote that her intention was to use her art to express things 'deep in the bottom of life' – 'the tempests, buds, wounds and genitalia that provoked my anxiety'. Perhaps unsurprisingly given this desire to expose the 'hidden shadowy part of life on earth', her work attracted the attention of leading psychiatrists. Dr Shihō Nishimaru, a professor at Shinshu University in Matsumoto who specialized in studying geniuses, visited Kusama's second Matsumoto show and was sufficiently inspired to present a paper about her entitled 'Genius Artist Woman with Schizophrenic Tendency' at the annual conference of the Kantō Psychiatric and Neurotic Association, held at the University of Tokyo on 13 December 1952.

According to Kusama's autobiography, Dr Nishimaru advised her that she needed to flee her mother in order to escape her neurosis. Another psychiatrist, Dr Ryūzaburō Shikiba, is said to have been planning a book on Kusama's work and a national touring show. As well as resulting in treatment, all of this attention gave rise to a new psychological self-consciousness in Kusama, which she appears to have found liberating. As Alexandra Munroe has written: 'psychiatry gave Kusama what her parents had denied her: justification to express herself and freedom to be mad.' Kusama was now happy to declare herself a creator of 'psychoanalytic art'.

Despite making a series of rapid personal and professional breakthroughs, Kusama had begun to think that her future might lie abroad, where she would be able to 'communicate with a wider audience'. Foreign travel was

difficult to arrange at this time, but Kusama called on her expanding network of allies to help her achieve an exit. She had penned a letter to the president of France to tell him of her desire to visit his country; he reportedly wrote back to say that he had given instructions for information to be sent about the possibilities of participating in a cultural exchange programme. But first, warned *le président de la République française*, she must learn French! Kusama started lessons but found them difficult. Nonetheless, Dr Nishimaru was instrumental in her being recommended for a scholarship from the Japanese Ministry of Education, and in September 1953 Kusama was offered a place at the Académie de la Grande Chaumière in Paris.

Her imminent departure for Europe was reported in the local press – but the plan never came to fruition. One reason for this change may have been that Tokyo galleries suddenly came calling. In 1954, Kusama would have two solo exhibitions in the Japanese capital: first, in February, at the Shirokiya department store in the Nihonbashi district, where 72 works were shown, and then a further exhibition, of pastels, gouaches and watercolours, at the Mimatsu Bookstore Gallery in August. In May, her painting *Flower Bud No. 6* (1952) was selected to be featured on the cover of the leading art journal specializing in watercolours, *Mizue*. Inside, reviewer Masao Tsuruoka wrote glowingly of her 'microscopic worlds'. Further activity followed in Tokyo in October, when three of Kusama's watercolours were included in a group show, *Eight Japanese Women Artists*, at the Yōkōdō Gallery.

An important opportunity arose when the Brooklyn Museum announced that its international watercolour show for 1955 would have a Japanese section, a fact that in itself indicated burgeoning US interest in contemporary East Asian art. A selection committee was appointed and Kusama was one of a dozen emerging artists picked for inclusion. Prior to the opening of the *International Watercolor Exhibition: Eighteenth Biennial* in New York in May 1955, the Japanese works went on show at the Bridgestone Museum in Tokyo in January.

At the same time, Kusama's fifth solo exhibition in only three years was unveiled at the Takemiya Gallery; it had been arranged by her ally Shūzō Takiguchi. Another solo show of 15 watercolours followed in May at the Kyūryūdo Gallery, drawing interest from the successful novelist (and future Nobel laureate) Yasunari Kawabata, who purchased pieces that Kusama would remember as 'phantasmal works from this noisome period of my early youth' when she was producing her 'Toilet Art'. Critic Kenjirō Okamoto praised the manner in which Kusama 'combines various techniques from Cubism and Surrealism, such as décalcomanie and frottage, and makes them her own, getting unforeseen results from such juxtapositions'.

On the face of it, Kusama was making excellent progress. But, despite having just made a successful entry into the capital's art scene, she harboured serious doubts about her long-term prospects, especially given her fierce independence, which kept her aloof from the male-dominated *bijutsu dantai* art associations. Although barely in her mid-twenties, the astonishingly prolific Kusama was becoming well

established – and well known to the press. Unfortunately, much of the coverage focused on the fact that she was a woman. Her seeming eccentricity was also attracting attention. As one paper observed: 'there are some people who are telling others that those are paintings by an abnormal child or a crazy person.' Kusama said that the Japanese simply did not get symbolism.

The Occupation might have delivered significant constitutional benefits to women, but if it had granted them the right to vote in elections, it had hardly provided them with equality in the context of the Japanese art establishment – or indeed of everyday life. Kusama would later comment that Japan in the mid-1950s 'was still a feudalistic society and was very difficult for women. It was so terrible that a woman wearing a red dress could have disgusted people back then.'

The new Constitution might have pointed towards equal rights, but many conservative types were likely still to equate a woman in a red dress with a prostitute trying to attract custom from GIs. The bigger galleries were anyway mostly interested in showing Western modern art. So, encouraged by the Brooklyn watercolour show, Kusama now focused her ambitions on the US. American culture was heavily promoted in postwar Japan. Key scenes from US history were portrayed at the 'America Fair' in Osaka in March 1950; replicas of the Statue of Liberty and Mount Rushmore were among the exhibits presenting the wonders of the American Way of Life to freshly democratized Japanese visitors. Cultural exchange between the countries was fostered via the US Information Service (USIS)

in Tokyo and the nearly two dozen American Cultural Centers in other Japanese cities.

One result of this promotional campaign was that the work of US artists was suddenly comparatively easy to see in Japan. At some point in the early 1950s, Kusama had come upon a book about the American painter Georgia O'Keeffe in a secondhand bookshop in Matsumoto. She found the work compelling – she thought that O'Keeffe had been influenced by her exposure to Eastern art: 'her flowers are *Nihonga* flowers, with space opening around them, and even the leaves are Oriental.' There was something in O'Keeffe's painting *Black Iris* that she particularly responded to, but she seems to have been no less inspired by the fact that, as an independent-minded woman artist, O'Keeffe had succeeded in carving out a distinctive career in a professional environment so heavily dominated by men. Kusama determined that she should make contact with this American exemplar, so when she attended an exhibition of American art books in Tokyo in autumn 1955, she obtained O'Keeffe's contact details in New Mexico.

A correspondence began almost immediately. In a letter dated 15 November, Kusama told the US artist that she had been painting for half her life, since turning 13. Being now 'on the first step of [a] long difficult life of painting', she asked whether O'Keeffe 'would kindly show me the way to approach this life'. O'Keeffe replied kindly to Kusama's request on 4 December, though in terms designed to shatter any illusions her young Japanese correspondent might have about the US. 'In this country the Artist has a hard time to make a living,' she told her candidly. When Kusama sent

her new pen pal a package of 14 watercolours, O'Keeffe forwarded the work to the New York dealer Betty Parsons. Parsons evinced little interest, however.

Kusama was not easily discouraged. The work of Seattle's Pacific Northwest School had come to her attention via a September 1953 article in *Life* magazine, more readily available in Japan as a result of the Occupation. The mystically resonant abstract paintings of Kenneth Callahan, Guy Anderson, Morris Graves and Mark Tobey struck a chord with Kusama; their exploration of the artist's inner state suggested an extension of the idea of self-development in the *Nihonga* tradition, and she was attracted by their attempts at 'dealing with mysticism born out of mechanical civilization'. As such, Kusama was inspired to make contact with Callahan in Seattle, sending him a parcel of nine watercolours, which the US artist showed to local gallerist and art dealer Zoë Dusanne. She was impressed and wrote to Kusama in January 1956 to offer her a show 'in 1957, preferably in May'.

Dusanne's letter settled Kusama's destiny. She resolved to leave Japan and begin a new life in the US, first in Seattle but then proceeding to New York, the capital of the art world. Talk of her 'mental illness', she said, had made her position in the country of her birth untenable. Japan 'was too small, too servile, too feudalistic, and too scornful of women. My art needed a more unlimited freedom, and a wider world.' To signal her determination to start over, at some time before July 1956 she carried two thousand of her early works – largely executed in the *Nihonga* style associated with wartime propaganda – to the banks of

the Susuki River behind her family home, where she smashed them with an axe and then burned them. It was a brutal but effective way of dispatching the art lessons learned in her childhood.

In its unsentimentality and clarity of purpose, this act of destruction demonstrated the kind of unbending determination that Kusama would need – and would show again and again in the coming decade – to succeed in her new life. She had no desire to cling to her old creations and old ways of doing things. She would, she promised, create better works in New York. And the people in New York would understand those works better.

The preparations for her departure proved far from straightforward. Her visa application was complicated, and her US debut in Seattle was steadily pushed back from spring to autumn 1957 and beyond while the problems remained unresolved. Finally, after Kusama secured the requisite sponsor with the help of a well-connected relative who had worked as vice-minister of Foreign Affairs, December was settled on for the exhibition's opening. The Japanese press publicized the forthcoming show, the mayor of Matsumoto City arranged a farewell party for the departing artist, and then finally, on 17 November 1957, having been seen to the station by a large crowd of well-wishers, Kusama boarded her Northwest Airlines flight at Haneda International Airport, ready to start her new life abroad.

3

Netting New York

K usama's first exhibition on American soil opened on 8 December 1957. The show, at the Zoë Dusanne Gallery in Seattle, featured a mixture of pastels and watercolours, including *Ancient Ball Gown*, *Fire Burning in the Abyss* and *Small Rocks in China*. As Midori Yamamura has argued, the influence, or at least 'resonance', of the Pacific Northwest School can be felt in paintings that Kusama made in Japan before her departure for the US such as *A Gill* (1955), a large mixed-media work 'showing a primordial universe, indicating Kusama's continuing interest in the life cycle and its mystery'. She had given the painting to her friend Shūzō Takiguchi, but when her Dusanne debut was confirmed had asked to borrow it back so that she could include it.

Kusama's work was thus well adapted to its US audience and, she told Georgia O'Keeffe on 26 January 1958, the show drew a 'large number of people'. Just as important, as she wrote in the same letter, 'many went away understanding what I am trying to express in my paintings', although she confessed to a fear that her 'medium' – what she termed 'Oriental mystic symbolism' – was 'not so readily received'.

There was a party, reported in the local Japanese-American newspaper, to welcome the artist to the US, a radio interview on Voice of America and a few sales: all

in all, a decent start. But Kusama was too ambitious to remain way out west in Seattle for long. New York was the epicentre of the postwar art world and as such her target destination. When she at last arrived there, in June 1958, one of her first tasks was to go to the top of the Empire State Building so that she could look out over its streets. 'I aspired to grab everything that went on in the city and become a star,' she recounted.

The flight from Seattle had provided a premonition of the turbulence that would regularly shake her life in her new home. Lightning had streaked the sky as her plane passed over the Rockies, and Kusama had wondered whether she was destined to reach New York in one piece. Once safely touched down, she took up residence at the Buddhist Society on Riverside Drive, where Reverend Hozen Seki effected her first introductions in the city.

Kusama's early years in New York present a remarkable double narrative, simultaneously of great material hardship and extremely rapid artistic evolution. She arrived speaking very little English, with few names in her contacts book and a shortage of funds. There were limits on the amount of currency that could be taken out of Japan: Kusama had thus planned to bring 60 silk kimonos as well as two thousand artworks with her. In the event she had gone to Continental Brothers in Tokyo and changed a million yen into dollars – a significant sum in Japan, comparatively little when transported to the US – which she had then carried, she said, secreted in her shoes and sewn into her dress. Her new impecuniosity may have taken her a little by surprise. Across the coming years, airmail envelopes containing

further financial support from her family would arrive from Japan, but the exchange rate made it worth less than she might have hoped. As such, Kusama had to contend with harsh living conditions: her diet seemingly consisted mostly of potatoes and onions, supplemented on occasion by chestnuts donated by a friend, or by scavenged fish heads and cabbage leaves. An old door served as her bed. Heating was a luxury beyond her means, and the temperature in New York could drop very low indeed.

Kusama's visa required her to be enrolled as a student. The cheapest and least onerous option was the Art Students League, which cost around $15 a month and did not stipulate mandatory attendance. It would be some years before the US Immigration Department finally granted Kusama permanent residency, so in the coming period she would register at a series of schools, including the Brooklyn Museum. In the meantime, she needed to establish a place to live and work: the Buddhist Society's dorm was hardly a viable long-term option. So, three months after her arrival in the city, she moved to the first of a series of down-at-heel locations. By early 1959, her address was listed in the Manhattan telephone directory as 70 East 12th Street in the Lower East Side district of the city – which was both highly insalubrious and very popular with artists.

Kusama had touched down in Seattle before Christmas with a gallery already committed to showing her work. No equivalent arrangement was in place to provide a fanfare for her summer arrival in New York. In the run-up to her departure from Japan, she had asked O'Keeffe, as the person she respected the most, for advice. O'Keeffe had counselled:

'When you get to New York take your pictures under your arm and show them to anyone you think may be interested.' There was no magic formula for success, nor was O'Keeffe in a position to make things easy for Kusama. 'You will just have to find your way…as best you can,' she wrote.

O'Keeffe had invited Kusama to come and stay with her in New Mexico, and Kusama used her letter of 8 July, 'the eleventh day of my stay in New York City', to apologize for not taking up her up on her offer after her arrival on the West Coast. Money anxieties had made it impossible, she said. Only three of her works had been sold in Seattle and so she was under pressure to 'try to finance my stay and future plans by selling some paintings'. In this regard, she signalled that she had taken her mentor's advice to heart. 'I intend to compile a list of dealers and galleries from the phone book and visit each one with an armload of paintings,' she wrote. This she now did. 'I am truly amazed,' she noted, 'at the large number of galleries listed.' She quickly found her proactive boldness rewarded. E. Weyhe Inc. on Lexington Avenue, a bookstore with a gallery, took five paintings to sell in September, which was a start – though it hardly represented a shortcut to millionaire status. After deductions for commission, the painting *A Face*, sold in December, brought Kusama just $33.34.

It was an important breakthrough all the same. E. Weyhe may have provided a first contact point with East Coast collectors such as Mrs Samuel Louis Slosberg of Brookline, who then included Kusama in a show staged at her own residence in December. All successful artists need serious collectors, of course, and representation by a well-regarded

gallery was the surest conduit to connoisseurs and taste-makers. Therefore, it was crucial that at the same time as this Kusama was offered her proper New York gallery debut, in a group show entitled *Modern Japanese Paintings* at the Brata Gallery, a well-regarded cooperative space at 89 East 10th Street. This was exciting to Kusama not just because the Brata, founded by John and Nicholas Krushenick in 1957, enjoyed a good reputation among critics but also owing to its location: 10th Street was where Willem de Kooning, Franz Kline and other key members of the New York School, still in the ascendant in the late 1950s, had their studios. As such, it was the ideal place for an up-and-coming artist to make a statement.

* * * * *

'I am planning to create a revolutionary work that will stun…the New York art world,' Kusama had written to a Japanese magazine shortly after her arrival in the city. It was no idle promise.

It had not taken long for Kusama to begin to make an impact in her new home, and that impact would grow significantly in scale and resonance in 1959. In the first half of the year, her work was again featured in the Brooklyn Museum's *International Watercolor Exhibition*, with this important difference: she was now included in the US section, rather than the Japanese – proof that she was now a New York artist. The work displayed was, inevitably given the title of the show, a watercolour, a medium that had served her well to this point but that she would now begin to leave behind

as she developed a fresh style that she felt better expressed her adopted home.

The experience of being in New York would revolutionize Kusama's practice in extraordinary ways. From making spontaneous, smallish works in ink, pastel and watercolours, she would now find herself painting works in oils at heroic, Abstract Expressionist scale that required days and nights of obsessive, epic labour to execute. Not that she painted like Jackson Pollock or his peers: the works were all-over in design, but Kusama's was a 'cool' aesthetic with an 'endlessly repetitive rhythm' of brushstrokes in place of the hot, dynamic gestural mark-making of the Ab Ex painters.

New York, Kusama had observed, 'was inhabited by some 3,000 adherents of action painting' and she had no intention of emulating them. Where their brushstrokes were emotionally expressive, hers, she said, were 'repeated exactly in monotone, like the gear of a machine'. This may have been her response to New York, which she described as 'strangely mechanized and standardized'.

This new series made its public debut in a group show at the Nova Gallery in Boston in the form of *Large White Net*. In fact, the Infinity Nets, as the works would come to be known collectively, had developed from earlier watercolour experiments. In her youth, Kusama had painted the river behind her family home in Matsumoto, with its stones and eddies and swirls of water. On arrival in the US, after becoming fascinated by the distant wave patterns that she could glimpse far below on the surface of the sea as she flew from Tokyo to Seattle, she had begun a new series entitled *Pacific Ocean*. Not that the Infinity Nets, meditative and

obsessive in character and consisting of single-colour, serial, scalloped strokes of the brush, were intended as depictions of the water as such. Kusama herself described them as 'white nets enveloping the black dots of silent death against a pitch-dark background of nothingness'. Dots and nets had been part of her visual repertoire since she was ten, of course.

The second half of the year brought a huge breakthrough when Kusama held her first solo show in New York at the Brata Gallery in October. It proved a landmark debut; the influential critic Sidney Tillim declared Kusama one of the 'most promising new talents to appear on the New York scene in years'. The exhibition consisted of five large (*very* large – the biggest was 7 feet high by 14 feet wide) Infinity Net paintings, each comprising a mesh of small, endlessly repeated whorls and loops of white paint.

In his review in *Arts*, Tillim compared the paintings to Pollock's, with the difference that Kusama's was an 'art of withdrawal' or 'self-effacement'. Meanwhile, Dore Ashton in the *New York Times* wrote of Kusama's 'dry, obsessional repetitions' and declared the show 'a striking tour de force'. The influential critic and curator Lucy Lippard would say of the white-on-white paintings that the contrast between the net pattern and the painting's ground was so subtle that 'the initial impression was one of no-show': that is, at first the work was almost invisible. Calm where Pollock was turbulent, the canvases seemed to speak in a quiet, anti-expressive voice where the Abstract Expressionists shouted.

Another appreciative assessment of the exhibition appeared in *Art News*, written by critic and rising artist Donald Judd. 'The expression transcends the question of

whether it is Oriental or American,' he observed. 'Although it is something of both, certainly of such Americans as Rothko, Still and Newman, it is not at all a synthesis and is thoroughly independent.' Judd and Frank Stella both bought paintings by Kusama. Key figures of the emerging Minimalist movement, they seemed to recognize something of their own tendency in Kusama's repetitions.

Although Kusama, who became particularly close to Judd – he was, she said, her 'first boyfriend' – later claimed to have provided some of the inspiration for his box pieces, she denied any relationship between her own work and Minimalism. The latter was grid-based and had a heart of maths, whereas her art, though formally based on repetition, was looser, and designed, as Kusama herself put it, to generate a 'dizzy, empty, hypnotic feeling'. It was created under 'the spell of repetition and aggregation'.

A fire had been lit. A solo show followed at the Nova Gallery in Boston in November 1959, when Robert Taylor in the *Boston Sunday Herald* compared the look of the paintings to 'gigantic structures of lace': 'It has the effect somewhat of a net floating on the ocean, a veil shimmering across reality.'

On 8 January 1960, Takako Mori at the Gres Gallery in Washington, D.C. got in touch to suggest a possible spring show. It duly opened on 19 April. This time, the display of large Infinity Net paintings was supplemented with small watercolours and pastels. Kusama was pleased with the mixture of influential political figures, ambassadors and museum directors who attended. There was an appreciative review in the *Washington Post* by Leslie Ahlander, which

compared her to Mark Tobey and Jackson Pollock in her ability to make 'each single and minute thread of paint count in an overall composition', but that at the same time referred to Kusama as a 'self-taught artist who has evolved entirely alone', a characterization that would have pleased the fiercely independent artist, who disavowed any relationship to all '-isms'. Kusama liked the freedom of New York, which, as she was reported as saying in a newspaper article in October 1961, left her to forge ahead on her own. 'Today I am a member of no school, no trend, no movement,' she said. 'My work is my own. It is personal.'

The show was a modest commercial as well as a critical success. Purchasers included the Institute of Contemporary Art, Washington, D.C., the Canadian ambassador and the British art critic Sir Herbert Read. Read would prove a loyal supporter in the coming years, as would the Gres Gallery's director, Beatrice Perry, a contemporary Japanese art enthusiast who made great efforts on Kusama's behalf, helping to arrange a painting commission for Mrs Patrick B. McGinnis of Boston, and organizing monthly payments to Kusama, in an attempt to provide some much-needed financial stability. When Perry headed to Europe in the summer she talked enthusiastically about her new discovery, eyeing up solo shows for Kusama in London, Paris and Milan. Tokyo was flagged as a possibility too.

Despite Perry's commitment and obvious skill, Kusama hesitated over accepting formal representation from the Gres Gallery. Washington was an important outpost, but New York was the heart of the global art world, and Kusama hungered for representation from a gallery there. When

the loyal Perry included her in a group show of Japanese artists – alongside Yukiko Katsura, Minoru Kawabata, Kenzō Okada, Toshinobu Onosato and Takeo Yamaguchi – Kusama complained to Perry about her work's appearance in the exhibition, telling her that her 'dignity as an artist' had been 'wounded'. When an offer was forthcoming from the Stephen Radich Gallery in New York around this time, she accepted it and quickly made her debut in a group show.

Kusama wanted to make the biggest splash possible with her subsequent solo debut at the Radich gallery. Her inspiration knew no bounds, and she made her paintings with a similarly scant regard for physical limitations. At the 2 May 1961 opening at 818 Madison Avenue, she revealed canvases that were even bigger than those that had been on show at the Brata: the Infinity Nets were scaled up to more than 30 feet in width. Whatever the epic pretensions of the members of the New York School led them to do, Kusama could do better, the works seemed to announce. Not that she wanted to join the action painters: she wanted to subvert and supersede them. The paintings were so big and wrapped themselves so completely around the space that they suggested installation art and Kusama's desire to immerse her audience bodily in her vision.

An extensive publicity campaign accompanied the show, with ads in the *New York Times* and *Herald Tribune* as well as in art magazines. The reviews were respectful but perhaps lower-key than for her Brata debut: the *New York Times* reviewer, Stuart Preston, declared the artist's patience and focus 'astonishing' and allowed that 'the concentrated pattern titillates the eye'. However, he concluded that 'the

economy of means leads to economy of results'. Jack Kroll in *Art News* said: 'Miss Kusama paints with intensity, which may help to explain why the pictures lack any trace of ponderosity or rhetoric.' She was now selected to appear in the important group shows at the Carnegie Institute and Whitney Museum.

Interest was growing internationally as European curators now came calling. Henk Peeters, a teacher at the Arnhem Academy and a founding member of the Dutch avant-garde Nul artists' group, contacted Kusama after his attention had been caught by an ad accompanying the Radich show that ran in the multilingual French publication *Cimaise*. Peeters said he would be interested in including Kusama's work alongside that of Lucio Fontana, Piero Manzoni and others in a group show exploring new directions in art. Kusama agreed, and the pair became long-term allies.

After a delay, *Tentoonstelling Nul*, curated by Peeters, finally opened at Amsterdam's Stedelijk Museum in March 1962 featuring a 22-foot-long Infinity Net painting; Kusama was the only female participant. It began a long association with Dutch galleries. That year alone, Kusama would be featured in *Accrochage 1962* at Galerie A in Arnhem and *Nieuwe tendenzen* at Leiden's State University Gallery. Peeters's friendship extended to offering practical assistance too. Hence, when Kusama was asked to participate in a group show in Antwerp in June 1962, he arranged shipping of the paintings from the *Nul* show.

But Kusama's European debut had taken place after Udo Kultermann, the director of the Städtisches Museum in Leverkusen, West Germany, had invited Kusama to

participate in the prestigious survey show *Monochrome Malerei* (*Monochrome Painters*), which opened in spring 1960. Kusama was one of only two artists from America to be featured – the other was Mark Rothko. Europeans on display alongside them included the German Group Zero artists Heinz Mack, Otto Piene and Günther Uecker, the Italian artists Lucio Fontana and Piero Manzoni (again), and the French artist Yves Klein.

Kultermann described the featured Infinity Net painting, *Composition* (1959), as 'a brilliant variation of the internationally current concept of the monochrome'. Elements of this kind seemed to suggest a commonality between Kusama and artists of the emerging 'Nouvelle Tendance', or 'New Tendency'. She found herself regularly invited to participate in group shows in Europe, and appeared alongside members of Group Zero in Germany, Nul in the Netherlands, Azimuth in Italy and the Nouveaux Réalistes in France. In many respects, her inclusion was based on a misunderstanding. Where the New Tendency represented, as has been said, a cool art of objectivity that 'approached the impartiality of graphic data in a laboratory', Kusama's work was unmistakably the outcome of a vigorously handmade aesthetic. Her canvases' repetitions and patterns eschewed the machine-like finish of the new European movement.

Frequently associated at this time with avant-garde trends and tendencies – action painting, Surrealism, Minimalism, Pop Art, the New Tendency – in truth, Kusama was a one-person movement. As the *New York Times* reviewer Roberta Smith would remark some years later: 'Ms. Kusama is an artist who fits in everywhere yet stands alone.'

4

Boats and Other
Phallic Symbols

Kusama's participation in the Whitney Museum of Art's Annual – although she thought the Whitney 'hopelessly conservative' at the time – and the Carnegie Institute's *International Exhibition of Contemporary Painting and Sculpture* demonstrated the penetration she was achieving. But she was still not earning enough money to make ends meet. A large painting might bring in $350; smaller watercolours $75. The financial wisdom of signing a deal with the Radich gallery seemed less self-evident by mid-1961 and she terminated the contract. The inclusion of a large work in a group show there in September 1961 marked the end of the association.

In the same month, Kusama moved to a larger studio space at 53 East 19th Street, which would serve as her base until summer 1964. The Japanese-American architect George Kazuo Matsuda had been helping her with business matters since her arrival in the city; now they would share the third floor of the building. The sculptor Eva Hesse was a neighbour and they became close, while Donald Judd, Kusama's 'first boyfriend', lived on the top floor of the building. Her diet was still far from rich. The main ingredients in the meals

she prepared were onions and potatoes, which upset Judd when she cooked with her window open and the smell ascended to his study. 'Yayoi!' he yelled. 'How can I write with the smell of onions filling my room?'

Kusama now finally met Georgia O'Keeffe in person. Out of the blue, O'Keeffe telephoned her one day and explained she was in New York and wanted to pay her a visit. Was she free? Kusama was keen to get a photograph of them together but her camera was out of film; since her visitor was due to arrive in ten minutes there was no time to pop out to buy more. As a result, the visit went undocumented, although Kusama looked keenly at O'Keeffe, who was in her early seventies at the time, and noted that she had more wrinkles than she had expected.

O'Keeffe wanted to help Kusama and introduced her to her dealer, Edith Halpert, who bought a work. She again invited Kusama, who was suffering bouts of neurosis owing to the 'ferocity' of New York, to stay in New Mexico with her. Kusama never did make the journey out to Ghost Ranch, but, according to her autobiography, the pair would meet on O'Keeffe's future visits to the city. O'Keeffe even gave her a watercolour of a flower, which Kusama to her regret lost in a move.

Kusama was voracious for the life of the city. She visited New York's museums and galleries, making a study of everything from Egyptian art to Art Nouveau via American Arts and Crafts, and borrowed books on subjects ranging from Greek myth to Shakespeare from the New York Public Library and Columbia University, which she would sit up all night to read. Her principal language was now English:

'I communicated predominantly in English, did most of my thinking in English, and even muttered to myself in English.' Perversely, her commitment to absorb all these new influences meant that, in her decade and a half in the city, she never fulfilled her ambition to go and see the blooming Japanese cherry trees at the Brooklyn Botanic Garden so that, as she said, she could think about spring in her homeland.

'People called me an art maniac and a workaholic,' she remembered. The physical intensity and psychological focus of the process involved in making the Infinity Nets disturbed her friends: she would paint from before dawn till late at night until her studio was full of canvases covered with nets – nothing but nets. 'I would cover a canvas with nets, then continue painting them on the table, on the floor, and finally on my own body. As I repeated this process over and over again, the nets began to expand to infinity.'

One day she woke to find that nets had enveloped the windows of her studio. She touched them and they spread on to her hand. Panicking, she called an ambulance, which duly arrived to carry her off to Bellevue Hospital. This happened repeatedly, until the medics told her, not unkindly, she said, that she should seek psychiatric help. But she carried on painting, dreaming of removing herself to Texas, where she might buy 'a boundless expanse of grassy plains'. She dreamt of other things too. 'I wanted to have fun the way that some of my friends did, night after night, with one boy after another.'

Illness dogged Kusama. Beatrice Perry remembered her turning up sick and looking after her for a week to ten days.

Kusama spoke of the trauma of having as a child caught her father *in flagrante*. Beate Sirota Gordon, who was a friend to her in New York, suggested Kusama see a psychiatrist for her 'obsessive-compulsive neurosis'. In search of a cure for her mental struggles, as Kusama recounted later, she consulted 'antiquated Freudians' who all wanted to get her to talk about her mother. Such treatments did not suit her. 'The more I talked, the more haunting the original impression became,' she said. The upshot was that she 'felt worse and worse'.

* * * * *

Kusama's East 19th Street studio was located above a fabric shop, and tellingly her move there coincided with a radical shift in her practice, as she now began to make fabric sculptures. Perhaps part of the inspiration for this new departure also came from her wartime experiences in Japan, when she had been conscripted to make parachutes for the Japanese air force. Not that that explained the formal qualities of the stuffed protuberances, which were suggestive of phalluses. 'I began making penises in order to deal with my feelings of disgust towards sex,' Kusama later recounted. '…It was a kind of self-therapy, to which I gave the name "Psychosomatic Art".' But, as Mignon Nixon has noted, these objects also seemed to be 'offered up in parody of the phallic hyperbole of the atomic consumer age'.

Like the activity so central to their production, sewing, many of the objects Kusama chose to cover with the fabric sculptures were traditionally associated with the female domain: a spoon, a spatula, a pan, an ironing board, women's

high-heeled shoes. In this way, as Midori Yoshimoto has commented, she 'castrated the power associated with the phalli, turning them into benign elements that decorate women's domestic space'. *Accumulation No. 1* and *Accumulation No. 2*, respectively an armchair and a couch coated with phallic protrusions, made their debut in a group show in 1962 in an important new space for emerging artists, the Green Gallery. Featured alongside Claes Oldenburg, George Segal, James Rosenquist and Andy Warhol, Kusama was in excellent avant-garde company for what turned out to be one of the landmarks – 'ground zero', as Kusama put it in her autobiography – in the advent of the Pop Art movement.

Another Green Gallery group show featuring Kusama followed in January 1963. The other artists in *New Work Part I* again constituted a roll call of rising art stars, including Dan Flavin, Lucas Samaras, Larry Poons – and her friend Donald Judd. Kusama wrote a long letter to Richard Bellamy, the Green Gallery's director, in an attempt to persuade him to give her a solo show. He did not immediately agree (although he did at one point offer her representation), so she began to explore the possibility of renting a loft space where she could mount her own exhibition – an *Accumulation Room* filled with protrusion-covered objects. As she informed her old ally Beatrice Perry, she had in mind something along the lines of Claes Oldenburg's *The Store*, a shopfront he had opened on Manhattan's Lower East Side in 1961 to sell his unconventional work – slices of pie fashioned from painted plaster and so on – in a very ungallery-like manner.

Some relief was afforded Kusama when she was finally granted permanent residency rights in May 1963.

That at least resolved one source of status anxiety for her. But another – her position within the art world and representation by a gallery – remained. Beatrice Perry had been trying to establish a New York space for the Gres Gallery – which might have been an ideal home for Kusama – but this possibility now began to fade.

Not that Kusama was put off. As well as heroic productivity, she demonstrated remarkable fortitude and strength. 'She was tiny but macho,' one friend later recounted, and unstinting in her pursuit of new contacts. Carolee Schneemann recalled attending a gallery opening and Kusama asked her to point out the important men in the room. She was, said Schneemann, 'blatant and aggressive and overt' in her pursuit of patrons. Obviously successful too, since at the next opening she was accompanied by one of the people Schneemann had pointed out.

Kusama now met gallerist Gertrude Stein, who offered her a spot in a group show at her East 81st Street space in October and then, in December 1963, staged the first solo show of Kusama's new Accumulations era. Approached via a dark corridor, *Aggregation: One Thousand Boats Show* consisted of a room centred on a nine-foot-long rowing boat covered in soft phalluses. The boat was an item of street salvage retrieved by Kusama with the help of Donald Judd, who also served as Kusama's assistant in the onerous task of stuffing sacks to make the protuberances.

The surrounding walls, floor and ceiling were papered with black-and-white photographic reproductions of the boat – 999 images in total. The effect of such an accumulation of sameness in a small, enclosed space was

both hypnotically oppressive and strangely lyrical, as Brian O'Doherty noted in his *New York Times* review. *Aggregation: One Thousand Boats Show* was, he said, a 'genuine, obscurely poetic event [that] should not be dismissed as a surrealist caper. Kusama has produced an object and an environment that are weirdly moving.'

Kusama asked Rudy Burckhardt, who had famously documented Jackson Pollock at work at the start of the Abstract Expressionist revolution, to photograph the exhibition. The results included a shot of the installation with Kusama standing inside it, naked, with her back to the camera but her head half-turned to the viewer. Was this intended as a feminist statement, a rejection of the (male) gaze? It was extremely unusual for an artist to choose to be photographed in this way, but the intensity of Kusama's look turned the scenario, as Alexi Worth put it, from a 'frivolous Surrealist premise (Playmate in Penisland) into something unexpectedly somber and unsettling'.

Photography was a key tool in allowing Kusama to construct a distinct artistic persona for herself. The images produced at this time drew a great deal of attention because Kusama appeared naked in some of them. But in truth, Kusama had been keen to place herself physically, and by extension spiritually, in the middle of her works from the outset. As Laura Hoptman has noted, there is a parallel with Piero Manzoni here. Like her Italian peer, Kusama 'considered herself a living work of art and promoted herself as such', so that the photographs she commissioned should by rights be considered as more akin to artistic self-portraiture or performance documentation than publicity

images. Researchers trying to locate photographs of particular Infinity Net paintings may struggle to find ones in which the artist is not featured above, below or in front of the works in question.

Kusama early on developed the habit of dressing in clothing that matched or helped her merge with the work she had created. When she began making collages and montages early in the 1960s, she would integrate photographs of herself into the works. There is a highly unusual double exposure image in which a full-length portrait of the artist is blended with a negative image of an Infinity Net, so that the artist is subsumed into the pattern she has painted: 'the merger between artist and work of art is complete,' Hoptman concludes. Or, to adopt the artist's own terminology, Kusama self-obliterates in the work.

* * * * *

One day a female gallerist contact told Kusama to dress up as she wanted to take her to meet someone important – 'Joseph Something'. Kusama did not catch the name but he was supposed to be an interesting artist, so she put on a kimono and a silver obi and set off. The pair eventually halted some hours later outside an extremely simple-looking tract house in a country town 'worlds away from Manhattan'. Kusama could not have been more disconcerted when she laid eyes on its occupant. Dressed in a scruffy, torn jumper, the artist-object of their visit – Joseph Cornell, then around 60 years old – looked like a ghost to her. Despite this inauspicious beginning, however, it was with Cornell,

Kusama would tell Damien Hirst in 1996, that she would enjoy her 'longest relationship...as a lover'.

Like Kusama, Cornell was an outsider. Born in 1903, he had something of a mythical aura in the art world thanks to his eccentric and reclusive lifestyle. He had worked as a door-to-door salesman, in a plant nursery – an odd echo of Kusama's own background – and as a designer for *Harper's Bazaar*, before a solo exhibition in 1949 at the Charles Egan Gallery had established him as something of an art star. Suddenly his box assemblages, largely containing discarded objects of no obvious worth in themselves, became highly desirable objects. Nonetheless, he continued to live in very modest circumstances in a wooden cabin on Utopia Parkway, Flushing.

Cornell liked the company of women – he was known to make husbands wait in an adjacent room while he talked to their wives – but he had remained celibate. Now he fell for Kusama in a big way. The gallerist had asked Kusama to accompany her, as she knew her presence would put Cornell in a good mood and make her transaction with the artist easier. 'You are the most beautiful and adorable Japanese girl I've ever seen,' Cornell apparently told Kusama once the dealer had departed, happy to have secured a box piece. 'I believe it was love at first sight for Cornell when he first saw me,' Kusama remembered.

Cornell was smitten and began to send Kusama poems and love notes ('Yayoi, fly back to me!' 'K=kiss!'). She received 14 letters from him in a single day; she complained about his habit of telephoning her incessantly and his appearance – he put her in mind of Frankenstein's monster

or a tramp, she said. But he was kind and very encouraging about her work, which he would buy and recommend to others. A physical intimacy soon developed between them: they would sit on the floor of his unheated cabin to sketch one another naked.

Cornell lived with his beloved disabled brother, Robert, and his mother, who made a distinctive contribution to her son's relationship with Kusama. Mrs Cornell did not approve of girlfriends – they were a source of syphilis and gonorrhoea, she said, in an echo of the sort of thing Kusama's own mother used to tell her about boyfriends – and was in the habit of boiling any towels Kusama used when she visited, presumably to ward off sexual contagion. Catching her son and Kusama kissing one day, she doused them with water. To Kusama's disgust, Cornell responded by asking his mother for forgiveness. 'I have lost count of the times I thought about giving that fat old woman a good swift kick,' Kusama confessed. Robert's presence could also add piquancy to their interactions. On one occasion Cornell asked Kusama to undress as his brother had never seen a woman naked.

Cornell's biographer, Deborah Solomon, wrote of their relationship: 'He was 60 years old, and finally, at last, he kissed a woman on the mouth, and explored a woman's body with his hands.' Kusama offered a slightly different perspective on their compatibility when she told the writer Andrew Solomon: 'I disliked sex, and he was impotent; we suited each other very well.'

Kusama said she stopped their relationship because she needed more time to paint. But their friendship would

continue until Cornell's death in 1972. Kusama related visiting him after he had undergone prostate surgery. Initially she had tried to put off going by saying she was too busy or by mentioning that when Salvador Dalí invited her for drinks at the St Regis hotel he would send his Rolls-Royce to pick her up. Cornell responded by persuading a collector to fetch Kusama in a Mercedes and drive her out to Long Island, where Cornell was staying with his sister. The pair drew one another naked and went for a walk on the marsh. There, they kissed before 'Joseph pulled his thing out of his trousers and showed it to me,' Kusama remembered. 'It was like a big, desiccated calzone.' He asked her to take it in her hand, but it was 'indifferent to [her] touch'. On another occasion he began to strangle her, then ran away. When she found him he was on his knees, praying for forgiveness.

5

Macaroni, Love and Mirrors

Kusama's phallus-covered sculptures – aka the *Sex Obsession* series – were soon supplemented by her *Food Obsession* series. As Kusama said, 'I first brought the themes of sex and food to the contemporary American scene with my Psychosomatic Art. Like sex, food was also an object of fear for me and therefore an appropriate subject.' The two strands of her work were presented together in her next show, unveiled at New York's Richard Castellane Gallery in 1964.

The *Driving Image Show* was another immersive environment, consisting of a room suggestive of a domestic interior. There were items of phallus-covered bits of furniture, including a dresser table, but the space was also peopled with female shop mannequins that had been encrusted with hard, dry pieces of macaroni. The floor was likewise coated with a 'Macaroni Carpet', which crackled and crunched unsettlingly as audience members stepped on it. At the show's opening, the effect was further supplemented by the presence of two dogs in macaroni coats, which, according to Kusama, 'ran barking frantically through the legs of viewers who were screaming in fright at the sound of the macaroni cracking under their feet'. It was not Kusama's goal as an artist to put her audience members at their ease. Such

installations with their fashion mannequins, noted Lynn Zelevansky, 'both explore and satirize the construction of feminine identities…recall[ing] nothing so much as off-kilter dollhouses for life-size Barbies, stand-in humans subsumed by the patterns that threatened to overtake Kusama as a child'.

The show created a startling feeling of sensory overload, and as spectators stared into the space it seemed that the objects it contained began to blur into one another. As one critic wrote: 'separate, distinguishable things tended to dissolve in their all-over texture.' This effect of perceptual instability and corporeal commingling was reinforced in a photo-collage made by Kusama in which her head hangs uncannily above a macaroni dress held in front of her, seemingly blending into it. In another photograph, taken by Hal Reiff, the artist, her naked body sprayed with polka dots and otherwise wearing only high heels, adopts a pin-up pose atop the phallic protuberances that coat her *Accumulation No. 2* sculpture.

The *Driving Image Show* in some respects shared a consumerist focus with Andy Warhol's show of the same year at Eleanor Ward's Stable Gallery. For his exhibition, Warhol had produced items that simulated the packaging of popular grocery products – Brillo pads, Kellogg's corn-flakes, Del Monte peaches, Heinz ketchup – and displayed them in the manner of a stockroom. But where the Pop Art king adopted a non-judgmental and even celebratory attitude to the mass-produced items, Kusama's presentation expressed anguish at life's mechanical repetitions and the overabundance of 'stuff' – including pasta. As she later

told one journalist: 'Anything mass-produced robs us of our freedom. We, not the machine, should be in control.'

* * * * *

Kusama was on the move again. She now found herself sharing a space with fellow Japanese émigré artist On Kawara at 404 East 14th Street. Claes Oldenburg also lived in the building (Kusama would claim that Oldenburg had got the idea of making soft sculptures from her and that Oldenburg's wife, Pat, would later implore her, 'Yayoi, forgive us!'), as did the 'godfather' of Pop Art, Larry Rivers. The lobby must have resembled an artists' convention some days. In her autobiography, Kusama recounted accompanying a guest down to the foyer one evening and running into Rivers, who was with a 'bevy of fashion models'. Rivers thought Kusama's shabby companion was a hobo, and was reportedly amazed to be told by her later that the 'homeless guy' was actually Joseph Cornell.

No fan of group shows – she was her own movement – Kusama had nonetheless accepted the need to participate in them when they might help to promote her interests. She contributed three new works – *Accumulation* (1963), *Ten-Guest Table* (1963) and a collage, *Accretion* (1964) – to *The New Art* at the Davison Art Center at Wesleyan University in Connecticut in 1964. The exhibition featured a cluster of rising Pop Art stars, including Warhol, Roy Lichtenstein and Robert Indiana. Its catalogue boasted an introduction written by Lawrence Alloway, who is regularly credited with coining the term 'Pop Art' and who

was then curator at the Guggenheim Museum in New York. Kusama likewise participated in *Best of 1964* at the Southampton Art Gallery on East 72nd Street.

Kusama's connection to the Zero and Nul groups gave her work continuing visibility in Europe, and she spent an increasing proportion of her time on the other side of the Atlantic. In June, an Accumulation sculpture from 1962 was featured in the travelling show *Mikro-Nul/Zero* in Rotterdam. Otto Piene, a founder of the German Zero Group, also included four of her Infinity Net paintings in an exhibition in October about artists' fascination with light and attempts 'to transform its unexhaustible energies into human measures'. (The show, entitled *Group Zero*, travelled to the Washington Gallery of Modern Art, Washington, D.C., in January 1965.) There was also an appearance in the survey show *Aktuell 65* in Bern, Switzerland, dedicated to 120 artists associated with the New Tendency movement. In March, Kusama's work made the cover of *De nieuwe stijl*, edited by Henk Peeters and others; an interview between her and Gordon Brown, the chief editor of *Art Voices* and another important ally, was featured inside. An accompanying show opened the following month at Galerij de Bezige Bij in Amsterdam.

Even better was a show at the Stedelijk Museum in the same city featuring Zero, Nul and other avant-garde contemporaries, including the Gutai from Japan. Peeters had suggested *One Thousand Boats* for inclusion, and it proved a hit; images of the work were widely reproduced and afterwards it was donated to the museum. Kusama certainly knew how to make an impression. Dubbing her 'The First Obsessional Artist', Gordon Brown wrote an article describing the scene at the

official opening of the show when Kusama, who had just flown in from New York, greeted her guests dressed in 'unusual attire which consisted of red tights and shoes and jet-black coat of gorilla fur exactly matching the color of her hair'.

The culmination of all this activity was a solo show – Kusama's first in Europe – at the Internationale Galerij Orez in The Hague in May 1965. Both stuffed protrusion- and macaroni-covered objects were featured, and the gallery now became Kusama's agent in Europe.

* * * * *

The *New York Times* had declared the *Driving Image Show* a 'must-see'. Her next US solo exhibition, also at the Castellane Gallery, which had now relocated to 764 Madison Avenue, proved equally unmissable. *Floor Show* opened on 3 November 1965 and contained several large Accumulation works, including a phallus-coated *Baby Carriage* and a work from 1962 entitled *My Flower Bed*. There is a photograph of Kusama lying coiled on the large organic-looking construction's bedspring base, her eyes watchful, her pose semi-foetal, as the flower looms with serpentine menace above her. The stalk-like element was made from stuffed gloves provided by Kusama's father, to whom she had written requesting two thousand pairs; many dozens were dispatched by way of return, but Kamon expressed a concern that customs officials might become unduly interested if he sent a much larger number.

The show also featured *Infinity Mirror Room – Phalli's Field*, which marked another important shift in Kusama's output. As Midori Yamamura has noted, the change coincided

with the rise to prominence of behavioural psychologist Timothy Leary and his promotion of hallucinogens to open the doors of perception. Kusama said she first tried non-prescription psychoactive drugs at around this time, and she would now find herself increasingly joining the psychedelic revolution. Like *Driving Image Show*, *Infinity Mirror Room* again presented a walled-in, immersive environment: the floor was completely carpeted with stuffed phallic protrusions, which on this occasion were infinitely multiplied and repro-duced in the mirrors that covered the walls and ceiling. This was Kusama's first mirrored-room environment, something that would become a staple of her practice in her later career in the form of the ongoing series of Infinity Mirror Rooms.

This adoption of mirrors marked a major turning point in her artistic progress. Here the infinite – hinted at in the repeated whorls of her earlier paintings – had been achieved for once without the need for obsessive, debilitating manual exertion. The disorienting repetitions of *Aggregation: One Thousand Boats Show*, with its 999 photographic reproductions, or the hundreds of stuffed protuberances of *Ten-Guest Table* (1963), which had taken a month to make, were repeated and infinitely magnified here through the less labour-intensive means of mirrors. Mirrors were a labour-saving portal to infinity.

Another striking feature was the polka dots that covered the phallic protrusions. Though they had featured in her visual repertoire since she was a child, this was the first time they had figured so prominently. Kusama was not the only artist working with dots – a parallel might be drawn with Roy Lichtenstein's approximation of Ben-Day dots in

his comic-strip works or the Op Art paintings of Bridget Riley – but Kusama's explanation of the meaning of hers certainly set her dots apart. She said that her dots represented sexually transmitted diseases such as gonorrhoea and syphilis. Like the mirrors, the polka dots would become a signature element of her future oeuvre.

Infinity Mirror Room – Phalli's Field was a major breakthrough for Kusama, so she was distraught when Lucas Samaras, who had not previously been working in that vein, staged a mirrored installation of his own shortly afterwards. His work was shown at the prestigious Pace Gallery, a location that would automatically give his work great visibility. According to Kusama, when she discovered what had happened, she threw herself out of her apartment window. She had not forgotten her sense of betrayal more than three decades later. 'Lucas Samaras is always copying other artists' work. His work lacks originality, I think,' she would say in a 1998 interview. 'He made the mirrored room series inspired by my work.'

It was Kusama's fate to find herself continually ahead of the pack. She had moved to making three-dimensional sculptural objects at just the moment that large-scale abstract painting had exhausted itself. She had also started making collages featuring near-identical ready-made objects: adhesive labels, toy money. As Lucy Lippard pointed out of works such as *Air Mail Stickers* (1962), 'Yayoi Kusama anticipated Warhol's repeated rows of soup cans, money, green stamps, and photographs with her own repeated rows of mailing stickers used non-objectively.' Kusama was regularly the first to intuit wider shifts in art-making practice, but was

destined not to be rewarded for her remarkable vanguard sensibility – at least for the time being.

* * * * *

The opening months of 1966 were very busy for Kusama and would find her flying back and forth between the US and Europe. The *Driving Image Show* was due to travel to the Galleria del Naviglio in Milan for a late January opening, and Kusama suddenly found herself with the responsibility of arranging (and paying for) transportation of 30 items from New York when Albert Vogel and Leo Verboon of Galerij Orez failed to sort out the shipment. Her friend Lucio Fontana offered her studio space, so on arrival in Italy she was able to produce a further eight pieces. In return for her friend's generosity, she gave Fontana a suitcase covered with phalluses.

After Milan, Kusama travelled to Venice, then on to Switzerland and the Netherlands. But she was back in New York in time for the opening of her first multimedia show, again at the Castellane Gallery, in March. *Kusama's Peep Show* (aka *Endless Love Show*) consisted of a large hexagonal chamber, painted black on the outside but lined with mirrors on the inside. Visitors could peer into it through one of two peepholes as, to the accompaniment of a soundtrack of Beatles songs, coloured lights flashed on and off inside, their reflections multiplying endlessly in the mirrored interior. This was infinity in a box – and, as one *New York Times* writer described it, 'an airless brightness as vast and as alienating as outer space'. 'This was the materialisation of

a state of rapture I myself had experienced,' noted Kusama in her autobiography.

Initially Kusama had wanted the lights in the chamber to flash the words 'Love' and 'Sex'. When this proved impossible, she produced badges bearing the logo 'Love Forever'. Love would become a major theme of her work in the coming years as the counterculture took hold and the sexual revolution advanced.

Kusama was back in Europe in April for a group show in The Hague, appearing on a TV show about the Zero group before travelling on to Germany. She took the opportunity to make new pieces during a stay in the artists' colony of Halfmanshof when a fresh iteration of the *Driving Image Show*, curated by Udo Kultermann, was mounted at the Galerie M.E. Thelen in Essen. A local newspaper reported: 'Everything in this show is different: macaroni and noodles are spread out on the floor. Beat music sounds from the loudspeaker. A blue TV set gives the local news. Three window-mannequins stand painted with dots. All the objects in the room have the measles: chairs, tables, ashtrays – even the cigarettes.'

The show was so surprising and unusual that it made people laugh, the reporter said. The solemnity of the artist herself, who was present and was interviewed for German television, offered a striking contrast with her work. 'In an intense pink kimono the small Japanese artist Yayoi Kusama moves around with a great deal of make-up, a Grecian hairdo and much perfume,' the paper noted. 'She never smiles.'

* * * * *

During the *New Art* show at Wesleyan University in 1964, Kusama had been contacted by Herbert Read, who was visiting professor there at the time. He had previously admired her paintings and he now felt moved to write to Kusama to express his admiration for her new sculptural works. Kusama had spotted an opportunity and had asked the esteemed art critic to write a text for her *Driving Image Show*. He was happy to oblige and wrote about his initial encounter with Kusama's work at the Gres show in Washington, D.C., when he 'at once felt that I was in the presence of an original talent'. In the text, he was interested to make a bridge between those earlier Infinity Net paintings – 'without beginning and without end, without form and without definition', which seemed to 'actualize the infinity of space' – and the new sculptural works.

But Read had a question for Kusama too. Her progress from painting to sculpture had been made with astonishing rapidity. Acknowledging that she was perhaps 'already "way ahead" as they say here', he now allowed himself to 'wonder where you go from here'.

He was about to discover the answer.

6

The Public Artist

For a few years now, Kusama had shown only a fleeting interest in the old clichés of the artist's life. Paintings safely hung on a gallery wall to be quietly appreciated, and expensively purchased, by a select audience of collectors and aficionados had already given way to more challenging fare such as phallus-barnacled objects and immersive, infinitely reflecting mirrored rooms. But in 1966, Kusama's practice would morph and radicalize in unprecedented ways as she stepped decisively away from the commercial gallery system to become a public artist specializing in the emerging medium of performance.

Kusama's first known public performance was *14th Street Happening*. It took place without much fanfare on the sidewalk outside her East 14th Street loft. The script could hardly have been simpler: Kusama reclined on a rectangular white mat covered with red-and-white polka-dotted phallic protuberances as curious passers-by looked on uncomprehendingly.

This initial foray into performance art was documented by photographer Eikoh Hosoe as a slide projection. Shortly afterwards, Kusama called on Hosoe's services again to photograph the more elaborately staged *Walking Piece*. For this, the artist attired herself in a pink floral kimono in

order to wander, decorative parasol in hand, through the desolate industrial landscape of Lower Manhattan.

Kusama had customarily worn modern dress in Japan. In New York, however, she might adopt traditional Japanese clothing, seemingly as a means of underlining her otherness as an Asian woman in the overwhelmingly white, male world of American art. This otherness provided the focus of the final version of *Walking Piece*, in which Hosoe's colour slides show the artist adrift in a fallen urban wasteland, an exotic floral outlier amid the grim symbols of alienated modern Western life: shop façades plastered with cheap ads, streets dotted with semi-abandoned cars, a homeless man asleep at the foot of a tree. The sequence ends with Kusama raising her sleeve to wipe tears from her eyes and turning her back on the camera as she walks into the middle distance.

In June 1966, Kusama once again appeared in public in a kimono. The location this time was not Manhattan but Venice, where the 33rd Biennale was under way, and she was to be found standing amid a field of 1,500 mirrored plastic balls, whose reflections created an illusion of an infinite reality. *Narcissus Garden*, prominently located in the Giardini next to the Italian National Pavilion, has sometimes been characterized as a 'guerrilla' intervention in the official proceedings, but in her autobiography Kusama pointed out that, although she was not a formally invited participant, she had been given permission to exhibit by the chairman of the Venice Biennale's committee after her Milan show earlier in the year.

The wisdom of granting that permission was called into question when Kusama, dressed in a gold kimono, started to sell the balls to passers-by – at 1,200 lire (or two

dollars) a pop. The mirrored spheres had been paid for with money loaned to her by her friend and mentor Lucio Fontana, famous for his 'slash' paintings and alongside whom Kusama had exhibited in European group shows. The organizers were outraged and complained that it was a breach of decorum to 'sell art like hot dogs or ice cream cones at the Venice Biennale'. Of course, had the price she was charging been more elevated, and the transactions conducted in a manner more appropriate to the inherent dignity of art gallery commerce, the operation might have passed uncensored. But that was precisely Kusama's point. She had erected a sign announcing 'Your Narcissium [*sic*] for Sale', which seemed to point an accusing finger at the self-regarding rituals of the art world.

Little wonder the sell-off was brought to a premature halt, although Kusama continued to hand out promotional flyers bearing a critical text praising the artist's 'original talent' and her work of 'strange beauty that presses on our organs of perception with terrifying insistence'. Stories about Kusama's assault on art's narcissistic worldliness proliferated in the press. These were regularly illustrated with a photograph of Kusama, now dressed in a red leotard, posing among the reflecting spheres. Kusama knew how to capture the media's attention; a talent she would develop and exploit in the coming years.

Before returning to New York, Kusama travelled on to England, where she visited the author of the adulatory text she had been handing out in Venice – Herbert Read. It sounds like a surreal occasion. Kusama described her host as 'every inch the aristocrat', but in truth Read, the

son of a farmer awarded a knighthood for his contributions to literature, was as quirky and hard to classify as his visitor. Kusama recalled being photographed with viscounts and earls at a reception Read – an academic anarchist in a bowtie – held in her honour.

* * * * *

In her autobiography, Kusama recounted gathering a group of young hippie performers in front of St Patrick's Cathedral one Sunday in January 1967. While mass was being conducted inside New York's great Catholic hub, Kusama and her followers performed a *Body Paint Festival*. Clothes were removed, US flags were burned, and Kusama encouraged the flames by adding Bibles and draft cards to the fire. Kissing and other sexual acts followed as a crowd assembled and cries of 'Blasphemy!' rang out until the arrival of the police brought proceedings to an end.

When word got out, a West German television company got in touch to express an interest in broadcasting a Happening. Kusama agreed, suggesting her studio and the inside of the mirror room that she had created for *Love Forever* as the optimal setting. Journalists were invited along to watch as 'a living sculpture [of men] writhed underneath the pulsating colours – a group having sex'. Kusama noticed that the female onlookers' 'eyes glistened with a peculiar light as they peered at the tangle of male bodies', while among the male observers 'a few had undone their zippers and were busy masturbating'. The performers painted one another with polka dots, 'the trademark of the Kusama Happenings'.

Painting the body with polka dots, said Kusama, 'caused that person's self to be obliterated and returned him or her to the natural universe'.

The times, as Bob Dylan had sung a few years earlier, they were a-changin', and Kusama was adapting her approach to art-making to change with them. Nudity was becoming a more regular, if hardly uncontroversial, public spectacle by 1967, when the Haight-Ashbury district in San Francisco was the epicentre of the Summer of Love, and when the counterculture, with its values of free love and questioning of authority, was becoming increasingly visible on main street.

As theatre writer Scott Miller has commented: 'nudity was a big part of the hippie culture, both as a rejection of the sexual repression of their parents and also as a statement about naturalism, spirituality, honesty, openness, and freedom.' The rock musical *Hair*, which opened in a small theatre in New York in 1967 and graduated to Broadway in 1968, brought the political values of nudity to the mainstream in a famous (albeit very brief) scene, as well as providing several anthems of the anti-Vietnam War peace movement. Protests against the war were growing in size and intensity, and the Civil Rights Movement leader Martin Luther King warned, 'If America's soul becomes totally poisoned, part of the autopsy must read "Vietnam".' Given her own upbringing in Japan during the war, with its devastating termination in the bombings of Hiroshima and Nagasaki, it was unsurprising that Kusama should become so involved in the anti-war protest movement.

There was likewise a move in the art world towards what art critics Lucy Lippard and John Chandler dubbed the

'Dematerialization of Art', which foregrounded 'ultra-conceptual' work that could escape ready commodification in the capitalist art market. After the fantastically labour-intensive Infinity Net paintings and Aggregation sculptures, Kusama largely dematerialized her art practice as she relaunched herself as the High Priestess of the hippie scene and the orchestrator of Happenings and performances involving audience participation. These were increasingly mass-public events; they were also increasingly sex-centred. Some of her supporters, not least Joseph Cornell, disliked this shift in direction.

Nudity and sex were key elements in the performances, then. Yoko Ono's *Film No. 4* (1966–67), more commonly known as *Bottoms*, had recently been released, its close-up shots of people's behinds flashing across the screen in an anti-war gesture: 'String bottoms together in place of signatures for petition for peace,' it urged. The feature-length version was initially banned by the British Board of Film Censors. Kusama would meet similar resistance to her nudity-for-peace performances. But there was another essential element to all of her performances: Kusama's signature polka dots.

On 16–18 June 1967, Kusama presented *Self-Obliteration: An Audio-Visual-Light Performance* at the Black Gate Theater in the East Village, New York, with a soundtrack provided by the 'music machines' of Fluxus artist Joe Jones and his Tonedeafs. Spectators were charged an entry fee of $1.50 and promotional materials promised that 'during the course of the happening Kusama will obliterate her environment, live bikini models and herself. All will be asked to wear polka dots for a polka dot dance party.' As Kusama explained, 'Everything originated from polka-dots on a canvas, spilling

forth onto the easel, the floor, the people, with everyone finally painting themselves, each other and the floor.'

Shortly afterwards, for the same fee, spectators in the hippie colony of Woodstock were invited to witness the same performance, as well as *Horse Play*, which involved Kusama covering horses with white polka dots. For this upstate spectacle, held in the location that would become synonymous with the counterculture generation after Wavy Gravy promised 'breakfast in bed for 400,000' people during the three-day 'Aquarian Exposition' music festival held there in summer 1969, Kusama's flyers emphasized 'the importance of Obliteration, Extermination, Emptiness, Nothingness, Infinity, Endlessness'.

Washington Square Park and Tompkins Square Park in New York provided the setting for weekend *Body Festivals*, where Kusama and fellow Japanese artist Minoru Araki invited counterculturally engaged passers-by to strip down and be adorned with polka dots. 'I came to Tompkins Square Park because it is the nest of the hippies,' Kusama told one newspaper. 'They like to paint the body nude...They understand it.' In keeping with this, accompanying leaflets urged the hippies in attendance to 'live with illusions...Love yourself beyond the point of vanity – with polkadots.' 'Please the Body' and 'Learn, Unlearn, Relearn,' pleaded press releases.

These activities began to capture press attention and Kusama, now the director of 'Happening Poster Corp.' and attired in bright red tights, a bodysuit with white spots, and a red cowboy hat with similar white spots, became known as 'the Priestess of Nudity', 'the Priestess of Polka Dots' or, simply, 'Dotty'.

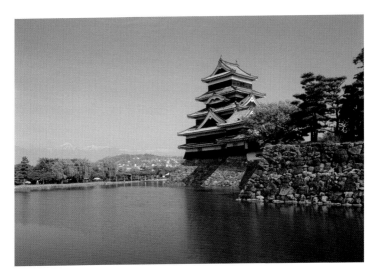

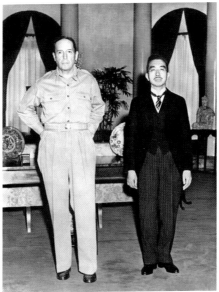

Top – Kusama was born in Matsumoto City in the cradle of the Japanese Alps.

Above – General Douglas MacArthur and Emperor Hirohito in 1945.
Japanese society changed radically during the US-led occupation.

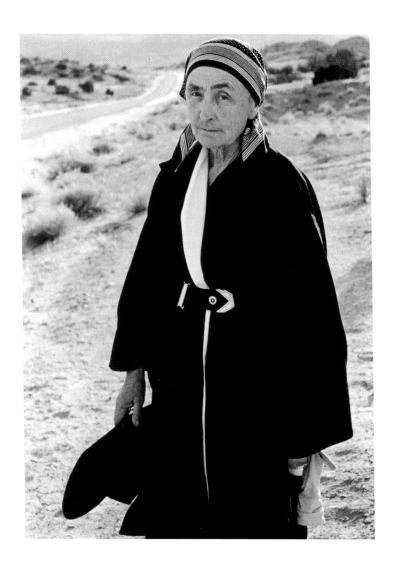

The discovery of Georgia O'Keeffe's work had an important influence on Kusama.
The two women corresponded and eventually met in New York.

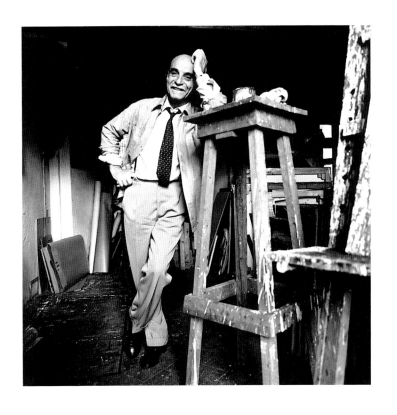

The Italian artist Lucio Fontana supported Kusama's creative activities in Europe, not least her independent contribution to the Venice Biennale in 1966.

As a Japanese woman, Kusama cut a distinctive figure in the largely white, male art scene of the 1960s. Stedelijk Museum, Amsterdam, 1965.

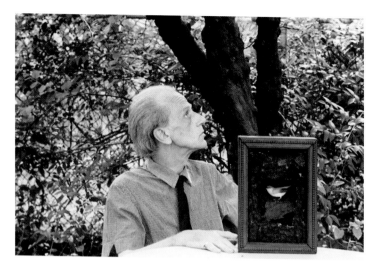

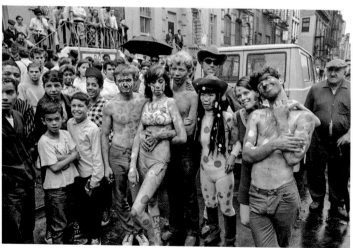

Kusama had a long relationship with the pioneering assemblage artist Joseph Cornell (top), who supported her artistic activities but did not approve of her increasingly sexualized performance-based work in the later 1960s (above).

In spring 1969, Kusama staged a 'Bust-Out' Happening with the hippie scenester and former presidential 'love candidate' Louis Abolafia in Central Park, New York.

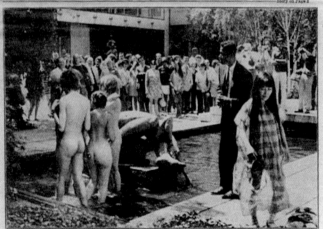

DAILY NEWS

NEW YORK'S PICTURE NEWSPAPER ®

Vol. 51. No. 52 New York, N.Y. 10017, Monday, August 25, 1969 WEATHER: Sunny and hot.

8¢

FEARFUL BERET BLEW LID OFF

His Role in Viet Slaying Bared

— Story on Page 2

But Is It Art? Security officer Roy Williams pleads with nude young men and women to leave Museum of Modern Art fountain, where Maillol's sculpture, Girl Washing Her Hair, reclines. Impromptu nude-in was conception of Japanese artist Yayoi Kusama (right). Crowd takes it in stride. (Some took strides to get closer).

—Story on page 4

Our Noisy, Dirty, Crowded Subways—See Page 3

Kusama's *Grand Orgy to Awaken the Dead* Happening at the Museum of Modern Art in New York in August 1969 made the front page of the *Daily News*.

Kusama made a triumphant return to the
Venice Biennale in 1993, this time as Japan's official representative.

Fellow Japanese female avant-gardist Yoko Ono was featured
alongside Kusama in the 12th Sydney Biennale, 2000.

Kusama touring the Pompidou Centre in Paris in 2001.

Kusama speaking at the opening ceremony of her exhibition
Eternity of Eternal Eternity at Matsumoto City Museum of Art, 28 July 2012.

To accompany a major retrospective of Kusama's work at Tate Modern in London in 2012, a giant statue of the artist was placed above the entrance to Selfridges department store as part of her collaboration with the Louis Vuitton fashion brand.

Kusama at work in her Tokyo studio, August 2012.

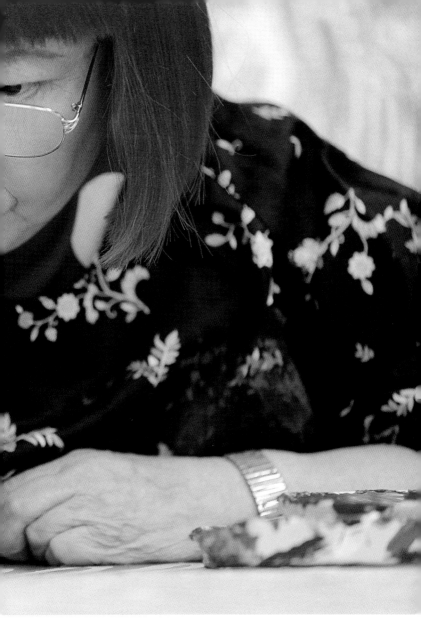

Kusama receiving the Order of Culture from
Emperor Akihito at the Imperial Palace in Tokyo on 3 November 2016.

The dot-centred performances spread, like the tablecloth pattern she had witnessed colonizing the universe when she was a child in Matsumoto. They had something of a cult-like character, promoted by Kusama in her accompanying flyers and press releases. The unifying idea was of 'self-obliteration' and 'becom[ing] one with eternity', and the ubiquitous polka dots, applied to the bodies of participants, have been well described as 'a Pop version of her signature dot motif'.

Kusama's 'Tea Dancers' performed 32 times at the voguish New York nightspot the Electric Circus in what appears to have been an audio-visual psychedelic spectacular to rival Warhol's Exploding Plastic Inevitable. Kusama continued to generate press releases for the media and handouts for members of the public. 'Become one with eternity. Obliterate your personality,' announced one. 'Become part of your environment. Forget yourself. Self-destruction is the only way out.'

The police usually turned up to close the events down, although Kusama recalled kindness from New York officers after she was arrested, with one going out to get her cake and coffee at 2.00 am while she languished in a cell. Realizing they were in the presence of 'Kusama the Naked Painter', other detainees began to ask if they could participate in the next body-painting performance. As she recalled in her autobiography: 'In the course of giving form to my ideas, I managed to break many of society's rules, exposing myself to time in jail, trials, and pursuit by the FBI.'

Kusama's ambitions extended beyond New York. At the beginning of September 1967, she took the performances to the Chrysler Museum in Provincetown, Massachusetts, with local papers saying the goal was 'to make people into

art'; there was television coverage too. Nationally, Kusama was increasingly being recognized as one of the leaders of the new hippie movement.

Kusama made a film documenting these activities with the avant-garde cinéaste Jud Yalkut. In an interview with Yalkut published in early 1968, she recounted that the film had been made across a period of three months, which took in the Gate Theater and the Happenings in Woodstock. Filming also took in body-painting parties with Kusama's Electric Circus dancers; the climax was shot at a specially mounted 'naked body painting orgy' in the Infinity Mirror Room at Kusama's studio on 14th Street.

Featuring a splendidly psychedelic soundtrack, the resulting 23-minute work, *Kusama's Self-Obliteration*, begins with images of Kusama's earlier pieces – *Aggregation: One Thousand Boats Show*, *My Flower Bed* and works featuring dots, lots of dots. It then shows the artist out in nature, placing polka dots on a horse (which she then rides), on the surface of a lake, a tree, a cat, a man, and in the landscape, before moving to the city, where the Statue of Liberty and other sites are speckled with measle-like additions. The short climaxes in a trippy, orgiastic scene featuring paint-smeared Summer-of-Lovers cavorting in a mirrored interior. Released in 1968, it won second prize at the Second Ann Arbor Film Festival and a jury prize at the Fourth International Experimental Film Competition at Knokke-le-Zoute, Belgium. Among other things, it was also selected for 'Steps towards a New Consciousness', part of the Whitney Museum's New American Film Makers series.

In autumn 1967, Kusama headed to the Netherlands.

Gallery shows in New York were hard to come by, but earlier in the year there had been the group show *Three Blind Mice* at the Stedelijk van Abbemuseum in Eindhoven in April, and then in Ghent in June. In October she opened a solo show with a performance involving painting naked men and women in fluorescent colours, which was very effective when the lights were then turned off. Her body-painting activities caused the authorities briefly to close a student music club in Delft when she asked attendees to take off their clothes while the Novum Jazz Orchestra played. According to Kusama, most people had left to attend sex parties in their apartments before the police arrived. She then led a protest against these actions, denouncing Dutch conservatism 'and demanding to know what harm there was in nudity'.

As she made her way across the country afterwards she continued to paint people with polka dots. There was a *Love and Nude Body Antiwar Parade* in a museum in Rotterdam, and Naked Happenings followed in Belgium and Germany.

Europe had become something of a second home for Kusama. In her autobiography she recounted a trip driving across the Swiss Alps, rock music blaring from the car radio and singing or talking continuously to keep the driver, an Italian architect, from falling asleep. 'We kept a revolver hidden in the car,' she recalled, 'and agreed that we would use it, if necessary, to kill any attackers.'

7

A Series of Explosions

Kusama returned to the New York streets in 1968. Her work now took a more overtly political turn as the *Body Festivals* were succeeded by a series of Happenings dubbed – in an allusion to the devastating bombings that had marked Kusama's youth as well as to the public nudity the events promoted – *Anatomic Explosions*. Performances staged in the business district or at major tourist destinations took on the character of demonstrations as young participants working under Kusama's direction danced naked, their exposed flesh decorated with polka dots – until, inevitably, the police arrived to stop the fun.

Politically, the atmosphere was souring and the police were much in evidence in breaking up street protests that year. Martin Luther King was assassinated in April, sparking violence across the country, and Robert F. Kennedy was killed on 5 June, just two days after Valerie Solanas, author of the SCUM Manifesto, had ascended to the Factory at 33 Union Square West and shot Kusama's friend and 'rival' Andy Warhol.

Performance locations for the *Anatomic Explosions* were strategically chosen to secure maximum attention. For the first in the series, on 14 July 1968, four naked dancers gathered beneath the statue of George Washington across from the New York Stock Exchange on Wall Street while

Kusama painted them with blue polka dots. 'Anatomic explosions are better than atomic explosions,' they declared. The artist was accompanied by her lawyer, who was on hand when the police arrived to break things up – but not, on this occasion, to make arrests. 'Nudies Dance on Wall St. and Cops Don't Pinch 'Em,' ran the headline in the New York *Daily News*.

A second *Anatomic Explosion* followed three days later, this time in front of the Statue of Liberty. The flyer for the event made an explicit connection between nudism and anti-capitalism – 'Nudism is the one thing that doesn't cost anything. Clothes cost money. Property costs money' – but, as Laura Hoptman has noted, the 'thin veneer of progressive political rhetoric did not disguise the fact that [the performances'] true agenda was Kusama's "symbolic philosophy with polka dots"'. Accordingly, onlookers were also urged: 'Forget yourself and become one with nature! Obliterate yourself with polka dots!' Polka-dotted performers would likewise unfurl a banner on the Brooklyn Bridge declaring: 'Kusama: Self-Obliteration.'

On 11 August, another *Anatomic Explosion* took place by the Alice in Wonderland statue in Central Park. 'Featuring me, Kusama, mad as a hatter, and my troupe of nude dancers…,' promised the promotional materials. 'Alice was the grandmother of the Hippies. When she was low, Alice was the first to take pills to make her high,' explained the event's MC, who then announced: '*I, Kusama, am the modern Alice in Wonderland.*' She had for years, she said, lived in a 'specially-built room entirely covered by mirrors' and had 'opened up a world of fantasy and freedom'. Participants

in her Alice ritual could now join her in this 'adventurous dance of life' by coming along to paint, and be painted by, their friends. The press release named the dancers who would be present and invited potential joiners to come and 'Paint the beautiful blonde Lydia Lee'. Tea would be served.

Photographs of the event show a clothed Kusama standing at the statue with her naked performers. The latter's bodies are decorated with polka dots and their faces are covered with masks, including one of Richard Nixon. Nixon's features were ubiquitous in that increasingly fractious presidential election year. 'Tricky Dicky' had secured the Republican nomination but it was not yet clear against whom he would be running. The incumbent president, Lyndon B. Johnson, had announced that he would not be seeking a further term in the White House, so when the 1968 Democratic National Convention was held in Chicago in August its principal goal was to select a new candidate; current vice-president Hubert H. Humphrey would emerge as the party's nominee.

The Chicago Convention drew headlines for other reasons after it became a locus for anti-war demonstrations. A youth festival had been proposed in the city by the 'Mobe' coalition (the National Mobilization Committee to End the War in Vietnam) and the Youth International Party (Yippies), who were putting forward their own presidential candidate: Pigasus, a pig. Tensions flared into full-scale rioting after police chose to disperse protesters by deploying tear gas. This was used in such plentiful quantities that it seeped into Hubert Humphrey's hotel room as he was showering in the Conrad Hilton. Televised

images shocked a watching nation – and perhaps, it has been suggested, helped secure a victory for the Republican candidate in the November vote.

Back in New York, Kusama staged another *Anatomic Explosion* on 8 September, shortly after the Soviet invasion of Czechoslovakia. 'I washed a Soviet flag with soap, because the Soviet Union was dirty,' she explained. The event had been planned to take place in front of the United Nations building, but had to be relocated after security guards intervened. On the corner of 42nd Street and First Avenue, Kusama's troupe stripped and began to dance before proceeding to the Tudor City apartment complex in east Manhattan to continue their activities among the Tudor Revival splendours of the residential development.

Not all was peace and love, even within the performance art community. Although Kusama hailed Charlotte Moorman as 'a pioneer of nudist art', she found herself in dispute with the founder of the Annual Avant-Garde Festival of New York after Moorman failed to invite her to participate in the 1968 edition. A former roommate of Yoko Ono and a friend of the likes of John Cage as well as a notable musician and performance artist in her own right, Moorman had created the festival in 1963. She found notoriety in 1967 as the 'Topless Cellist' after her semi-unclothed participation in Nam June Paik's *Opera Sextronique* at the New York Film-Makers Cinematheque: she had already played Massenet's *Elegy* wearing a blinking-light bikini and, now stripped of clothing on the upper half of her body, was just getting into the second movement of Max Matthews's *International Lullaby* when police officers intervened to stop the performance. Moorman

was charged with indecent exposure; by way of support, Jud Yalkut, who worked on *Kusama's Self-Obliteration*, filmed a restaging of the performance for use at her trial.

Kusama was naturally competitive, and when no formal invitation was forthcoming from Moorman for her to participate in the 1968 Annual Avant-Garde Festival, she decided to make an impromptu intervention. This caused Moorman to halt proceedings and try to get the police involved – on her side, this time. It seems that as Kusama's troupe had, exceptionally, remained clothed, there were no grounds for their expulsion.

In a letter to the *Village Voice* on 19 September 1968, Kusama denounced the festival – still popular with artists associated with Fluxus and the Happenings scene – as 'stale, stagy, and contrived': it lacked 'truly avant-garde events', she said. Presumably in reference to performances such as Moorman's in the *Opera Sextronique* at the Film-Makers Cinemateque, Kusama used the opportunity to claim credit for having taken 'nude art out of [the] theater and put it into the street – made it entirely nude instead of semi nude'.

Not all Kusama's activities were outdoor or overtly political in orientation – the Nirvana Headshop, a 'psychedelicatessen' in Queens, hosted her 'weekly flesh-in' in September, for instance – but her message was growing increasingly confrontational and hard-edged. Further *Anatomic Explosions* were planned for the HQ of the United Federation of Teachers on Park Avenue South and Wall Street. The press release for the latter, slated for 13 October, declared:

STOCK IS A LOT OF CAPITALIST BULLSHIT.

> *We want to stop this game. The money made with this*
> *stock is enabling the war to continue. We protest this*
> *cruel, greedy instrument of the war establishment.*

Not that Kusama had forgotten the importance of nudity
or – perhaps ultimately most important – dots:

> *OBLITERATE WALL STREET MEN WITH POLKA*
> *DOTS ON THEIR NAKED BODIES. BE IN...BE*
> *NAKED, NAKED, NAKED.*

The 46th quadrennial US presidential election was to be
held on 5 November 1968. The candidates were former
Republican vice-president Richard Nixon, the Democrat
Hubert Humphrey and the Independent George Wallace.
As the *New York Times* reported, two days before voting
was due to take place, Kusama arrived outside the New
York Board of Elections at 80 Varick Street accompanied
by a small troupe of male and female performers, naked
but with their heads covered with cut-out photographs of
the faces of Nixon, Humphrey and Wallace.

Kusama proceeded to daub their bodies with polka dots
while in a press release she encouraged voters to 'learn the
naked truth about the candidates' before casting their ballots.
'How do Nixon, Humphrey and Wallace look with their
pants down?' Kusama asked, commenting that 'the elemental
facts count most' and concluding: 'The basic sex drives of the
winning candidate will decide the fate of nations.'

As it turned out, Nixon triumphed in the ballot, putting
his sex drive firmly in control of the international situation,

and Kusama followed up his victory with a further action on 11 November. This time she descended on Reade Street and Broadway in Lower Manhattan with four naked protesters, whom she painted with polka dots as she handed out 'An Open Letter to My Hero Richard M. Nixon'. 'Our earth is like one little polka dot,' she addressed the president elect, 'among millions of other celestial bodies, one orb full of hatred and strife amid the peaceful, silent spheres.' The values of the unfallen world could be restored, however: 'Let's you and I change all that and make this world a new Garden of Eden.'

Kusama invoked her polka dots philosophy as she registered a plea for Nixon to rethink US involvement in Vietnam – and to take off his clothes at the same time: 'Let's forget ourselves, dearest Richard, and become one with the Absolute, all together in the alltogether.' The pair would 'soar through the heavens' and, as they did so, 'paint each other with polka dots, lose our egos in timeless eternity, and finally discover the naked truth'. The statement's philosophical and political pay-off – '*You can't eradicate violence by using more violence*' – was gently subverted by the deft absurdism of its expression: that wonderful image of Kusama and her 'dearest Richard', the new US President, stripped naked and daubing one another with painted spots somewhere in space. News of the protest was carried in more than a hundred papers after the Associated Press reported it.

There was little pause between the Happenings orchestrated by Kusama that month. Kusama's next public performance, a 'Grand get-together naked happening', was

announced for midday on 17 November. The location was the New York underground and the goal was to 'Transform the subway into Paradise'. Commuters should no longer 'remain strangers' with that 'girl or boy waiting for a train, sitting opposite you in miniskirt or slacks, or getting off at your station', she said. To help all potential inhabitants of this new underground Paradise overcome shyness and social atomization, she urged them: 'Let's all take off our clothes in the subway!'

The *Village Voice* reported Kusama's next venture, a *Homosexual Wedding* at the 'Church of Self-Obliteration', at 31–33 Walker Street. This took place on 25 November, many months before the era-defining Stonewall riots of June 1969. The ceremony was to be conducted by the 'High Priestess of the Polka Dots' herself, who declared: 'Love can now be free, but to make it completely free, it must be liberated from all sexual frustrations imposed by society.' She had designed a single-piece 'orgy' wedding gown to unite the happy couple, Falcon McKendall and John DeVries, because, she explained, 'Clothes ought to bring people together, not separate them'.

During the ceremony, Kusama reportedly intoned, 'Do you take this man to be your lawful wedded spouse?' over a Manhattan telephone book, before members of the wedding party stripped, painted each other with polka dots and ripped up the 'holy phone book' to make confetti.

The event clearly failed to capture the imagination of the *Village Voice*'s correspondent. 'Kusama, whose gross lust for publicity never leaves room for taste, managed to put on the year's most boring freak show for members of

the press this week,' the writer complained. 'Kusama is definitely suffering from over-exposure of over-exposure. Can anyone guess what my New Year's resolution will be?'

The *Village Voice*, the country's first alternative news weekly, had been set up specifically to provide coverage for the counterculture, so it was a worrying sign that Kusama's activities, however progressive and well intentioned, should be drawing such a negative response in its pages.

More traditional media sources were still interested in Kusama's Happenings, however, and Kusama was increasingly interested in going mainstream. Body painting got a demo on *The Tonight Show Starring Johnny Carson*. Also in November 1968, Kusama was invited to appear on *The Alan Burke Show*, a syndicated TV talk show that regularly covered countercultural subjects: controversial topics ranged from abortion to sex in suburbia and guests included a topless female pop five-piece and a nun who had quit her convent to become a go-go dancer. In such a context, what Kusama had planned – a small nude Happening – was not perhaps particularly shocking. After all, by this date the groundbreaking celebration of 'the Age of Aquarius', the hippie musical *Hair*, complete with nude scene, was running on Broadway.

In early December, Kusama found herself engaged to stage indoor naked Happenings. The location was New York's Fillmore East, rock promoter Bill Graham's companion venue to his Fillmore West in San Francisco where acts such as Neil Young and the Allman Brothers would shortly record live albums. The *Kusama Self-Obliteration Musical* was to form part of a diverse bill that also featured

a fledgling Fleetwood Mac. This was showbiz, but with a radical twist.

'Kusama offers the new way to happiness by smashing to smithereens the old social morality,' announced a flyer. '...Kusama asks you to become one with eternity by obliterating your personality.' A report in the performing arts magazine *Show Business* by editor and owner Leo Shull captured the scene at the theatre: 'half nude people ran in the aisles painting polka dots on customers or sticking decals over the women until a cop ran down the aisle and up on the stage, where a couple of friendly girls stripped him naked pronto too.'

The strains of 'God Bless America' and 'The Star-Spangled Banner' blasted from the PA as the performers gyrated, 'falling into the 101 Kama Sutra sex positions on the floor, while having themselves painted all over. Some kissed; others draped themselves in flags, carried photos of Nixon, wore CIA sweatshirts. The show lasted about 30 minutes,' concluded Shull. 'Two hours later they did a repeat.'

8

'Person of the Hour'

Spring 1969 saw Kusama and her entourage back in the streets. Towards the end of March, Kusama's fellow Japanese expatriate Yoko Ono trialled a new method of promoting peace and love in the face of the ongoing violence of the Vietnam War when she staged her first 'Bed-In for Peace' to mark her marriage to John Lennon. A few weeks later, on 6 April, Kusama mounted a 'Bust-Out' Happening with Louis Abolafia, a New York hippie scenester and friend to Warhol and Allen Ginsberg among others, at the Bethesda Fountain in Central Park. For this performance in the park, which reportedly revolved around a mock wedding, Kusama was dressed in a polka-dotted veil and a bra. Abolafia had presented himself as the 'love candidate' in the previous year's presidential election, a campaign celebrated in a poster showing him standing proudly naked, with only a hat to cover his manhood, under the caption 'What have I got to hide?'

The press release for the Bethesda Fountain Happening presented the would-be couple as 'the King and Queen of Love and Nudity' and claimed an audience of 100,000 people. The *New York Times*, perhaps more realistically, said that '500 hippies and 3500 "hippies-for-a-day" gathered for the event'. As part of the performance, Abolafia had planned to disrobe before throwing himself into the fountain,

but a significant police presence seemingly persuaded him that it might be wiser to keep his clothes on for this occasion. The event launched his campaign as the 'love candidate' in the city's upcoming mayoral election.

The 'Bust-Out' was not Kusama's most newsworthy performance of the year. That honour went to the bacchanalian *Grand Orgy to Awaken the Dead at MoMA* on 24 August. The press release explained: 'At the museum you can take off your clothes in good company: RENOIR, MAILLOL, GIACOMETTI, PICASSO.' Accordingly, Kusama led her troupe of performers into the Sculpture Garden of the Museum of Modern Art, where they proceeded to strip naked and strike poses in company with – and emulation of – the nearby sculptural works by the greats of 20th-century art. 'The nude has become socially acceptable among the more permanent residents of the garden of the museum,' Kusama added in a 'Sociological note' to her media statement, and 'Phalli', she continued, were '*à la mode*, particularly the harder varieties in granite, basalt and bronze'. So why should living flesh not be similarly celebrated?

The Happening, an assault on 'dead' art (Kusama dubbed MoMA 'the Mausoleum of Modern Art'), was rapidly brought to a halt by a security guard, who escorted the performers from the site. A photograph showing Kusama's nude models in the MoMA garden pond made the front page of the New York *Daily News*. 'But is it art?' questioned the headline underneath. 'Crowd takes it in stride. (Some took strides to get closer.)'

Kusama declared herself pleased with the coverage: 'the photos from this are all over the world in various

publications,' she told Udo Kultermann delightedly as she informed him about the success of her intervention, her first 'one-man show' at the venerable art institution.

'[A]s these events became the focus of controversy not only in New York but on a national scale,' Kusama remembered, 'I became a "Person of the Hour".' She was featured on the front page of the *Daily News* twice in a year – 'something not even Broadway stars managed to do,' she observed. Not everyone was impressed. In her autobiography she said that the morning after the MoMA intervention she found the sign outside her Sixth Avenue office vandalized and a stone was thrown through the window. She also remembered drunken Japanese men standing outside shouting insults.

Many of her former supporters in the art world were disconcerted by the new, more permissive directions she was pursuing – despite his personal devotion to Kusama, Joseph Cornell was disapproving – and she may have lost the financial support of her family. Accounts and pictures of her activities began to be carried in the Japanese press. She received a letter from her father, who was distressed after reading one such piece, in the magazine *Young Lady*. He asked her to stop her current activities. She refused.

Was Kusama's hunger for publicity destroying her art? The case has certainly been made. 'By the time leering articles about "Kookie Kusama, the Princess of Polka Dots" began appearing in men's magazines like *Bachelor* and *Sophisticated Swapper*,' one commentator has noted, 'they seemed to be elegies for a career that had descended into commercialism.' Interestingly, the same writer observes

that the Happenings period may have been the happiest in Kusama's career, noting that it is virtually only in this era that photographs show Kusama smiling.

It was certainly the most sociable period of her career. After years spent making extraordinarily labour-intensive paintings in an avowedly obsessive and inevitably solitary fashion, she found herself, as she said, a 'gang leader'. Her main rival in this was her friend and fellow gang leader Andy Warhol. They certainly moved in similar downtown milieus. 'We were like two mountains,' Kusama would remember.

She claimed that the Pop Art king wanted to do a silkscreen using a photo of her in the nude, covered with polka dots, and that his *Cow Wallpaper*, unveiled at the Leo Castelli Gallery in 1966, was 'plainly an appropriation or imitation' of her *Aggregation: One Thousand Boats Show*. Warhol had attended the exhibition's opening in December 1963 and – after first asking Kusama to tell him what it was – had declared it 'fantastic!' By way of return, there was a Warholian echo in the press release for the MoMA intervention when it said the 'cast' of performers would include the likes of 'Dill Dough, Infra Red, Looney Tunes', names that chimed with the monikers of Factory superstars such as Ultra Violet.

There are revealing parallels between Kusama's and Warhol's careers during this period. Both elided the traditional distinctions between the experimental underground and the commercial mainstream, and both pushed relentlessly to expand their practices into fresh cultural domains. In a magazine article on 'The New Nudity' published in *New York SCENES* in February 1969, Kusama explicitly

compared her working methods to those of Warhol: 'like Andy, I [am the] producer, not involved,' she said. They also shared a fascination with the mass media and the idea of celebrity. Kusama was as canny as Warhol, assembling and circulating press materials for all of her ventures.

As the 1960s drew to a close, it was said that Kusama was as famous as Warhol. Her business associate James Golata revealed that she hired a press clipping agency to test that theory – they were asked to document all press coverage 'where her name was mentioned more frequently than Andy Warhol'. In 1967, Kusama claimed that her collection of press cuttings was larger than her rival's. The following year, there were 161 articles about Kusama – but only one of them appeared in the art press. The art world did not approve. Kusama's 'lust for fame' would come to be criticized but some decades later Andrew Solomon provided important context in comparing her to Warhol. 'It should not be forgotten,' he wrote in *Artforum*, 'that she was less readily accepted since she was a woman; and battling for ground in a foreign tongue; and living in a society recovering from aggressive wartime prejudice against Japan.'

* * * * *

'Orgies, the sexual revolution, the gay revolution, unisex fashion – I embraced and addressed them all,' Kusama remembered with pride in her autobiography. Fashion in particular exerted an irresistible pull over Kusama. In defiance of 'mechanized conformity and machine-made mediocrity', Kusama urged people to 'See my "Peekaboo",

"See-Through" and "Open" pants, miniskirts and body stockings in the cloth and in the flesh. There are holes all over – holes that radiate life-giving energy – part of my Holy War against the establishment.'

'My designs have psychedelic overtones which stand for freedom in art and in life,' explained the 'Nudist Queen' in a press release. Polka dots – 'a symbol of peace, and also of the moon which maintains quiet over the whole world' – were much in evidence. 'Barewear' such as the 'Silver Squid' hooded dress exposed the breasts, while her Nude Fashion Company produced a Party Dress, which had 'holes cut out at the breasts and crotch to allow the wearer to have sex without disrobing', and there were dresses for up to 25 people. The women's magazine *Coronet* presented her 'two-in-one' dress for love-ins. Kusama herself was a keen adopter of her own styles. When working in her studio, she said she liked to put on a single-piece dress with holes cut out at crotch, backside and breasts. Her male assistants meanwhile were naked but for the modesty pouches they wore over 'their three-piece sets'.

One press release announced that 'mod, peek-a-boo, and see-through clothes for both sexes' were 'now being sold by department stores'. A deal with Marcstrate Fashions, Inc. made it possible to mass-produce designs for distribution across the US: like Warhol, Kusama was exploring 'factory' models of production. Not that scale was allowed to corrupt the underlying philosophy. 'All the clothes I designed and produced were, of course, decorated with polka dots,' said Kusama. Bloomingdale's in New York created its own 'Kusama Corner', while Kusama opened

her own fashion boutique at 404 Sixth Avenue. The space, said Midori Yoshimoto, served as a 'convenient camouflage' for her nude events, many of which took place on the building's roof.

Other business ideas proliferated. Kusama Enterprises, directed by the artist and managed by Golata, was established at 664 Sixth Avenue to serve as a source of 'films, environments, theatrical presentations, paintings, sculpture, happenings, events, fashions and body paintings'. The Nude Studio, which gave people a chance to participate in body painting, charged between $10 and $25 depending on how long the sessions lasted and the number of participants who disrobed. 'With thirty beautiful hippie girls on call, we had the biggest operation of its kind in New York,' Kusama said. There were males to hand too. 'I was the queen bee in my studio, with attractive young gay men buzzing around me,' Kusama noted of the set-up at the space she had now moved into in Greenwich Village. 'A customer would choose one of the boys by number, then take him into one of the many small rooms we had partitioned off, to paint his naked body.' She did not always appreciate the behaviour of clients from her home country. She grew so angry as a result of the attitude shown by a large group of Japanese businessmen towards the female models when they came to her studio for a body-painting party that she put up a sign at the door afterwards reading 'No Japanese allowed.'

Then there was KOK (an acronym for the Kusama 'Omophile Kompany), a 'homosexual social club' that, reported Kusama, saw her eulogized in the press as 'the Japanese flower who holds sway over some four hundred

homosexual men'. Not to mention the Orgy Company, aka the Kusama Sex Company, which hosted group sex parties. Sex toys and explicit photographs were available by mail order.

Even in this phase of her career, when she was so publicly aligned with the free love movement, Kusama's personal attitude to sex remained highly conflicted. Her Happenings urged sexual openness on a prudish public in need of liberation, but her own hippie tribe, she said, 'all called me "Sister" because to them I was like a nun'. She was 'neither male nor female. I am a person who has no sex.' Some of her followers tried to seduce her, which caused friction with the rest of the group, so she was forced to discipline her would-be paramours, she said. 'Cracking the whip against their white skin and seeing the red welts rise, I felt an indescribable pleasure. And some of them submitted eagerly to this punishment.'

Although she promoted public nudity, she said she 'hated the shape of the male sexual organ, and I was repulsed by the female organ as well. They were both objects of horror for me.' Given this dislike, why did she focus on the sex organs in her work? The reason, she explained, was that her 'Psychosomatic Art' was 'about creating a new self, overcoming the things I hate or find repulsive or fear by making them over and over and over again'.

Kusama's Self-Obliteration continued to be screened at venues around New York. Its creator spotted a commercial opportunity and set up the Kusama International Film Production Company, which, promoted via advertisements in the *Village Voice* and elsewhere, began to sell films of the

Happenings by mail order. One ad offered a host of new Kusama 16mm films – *Bonnie & Clyde, Madam Butterfly, Hamlet, Romeo & Juliet*, 'all starring gorgeous hippies' – that were 'available for rental to schools, museums and theaters'. Customers were asked to confirm that they were over 21 and to indicate by ticking a box whether they were 'incorruptible' or 'hopelessly corrupt'. Not that the venture would have been stress-free owing to censorship laws, as well as rights issues when a cinematographer who had filmed body-painting scenes in Kusama's studio reportedly started to circulate material himself. There was even an X-rated magazine entitled *Kusama Orgy*. Given her status as a sexual liberator and her ability to capture the headlines with her attempts to undermine restrictive social conventions, it is perhaps unsurprising that Kusama should have become involved in an erotic publication promising an 'orgy of nudity, love, sex & beauty for adults over 21'.

Kusama's ambitions seemed to know no limits. 'I wrote musicals, too,' she noted in her autobiography. One used 'the eight-headed serpent of Japanese mythology as a sexual symbol'; another adopted 'The Star-Spangled Banner' as its overture.

Kusama had also planned a stage work called the *Story of Tokyo Lee*. A draft contains a list of potential themes and scenes, including: 'toilet art; flower bed, suicide and blood-stained sheet; a boyfriend who is a gay prostitute; Happenings at the Statue of Liberty and the UN; plans to organize an international orgy.' The material was significantly autobiographical, as is clear from the final items on that list; indeed, at one point Kusama seemingly thought

of changing her own name to Lee Kusama. As she declared in her autobiography, 'The protagonist, Tokyo Lee, was me.'

Kusama collaborated with Gordon Brown in 1972 on a three-act play, *The Gorilla Lady Meets the Demons of Change*. This was to feature Kusama as the Gorilla Lady, who is swallowed by a snake, before being cut free by the Warrior, and is then 'reborn as a child dressed in white, the color of innocence and purity'. In keeping with the subtitle announcing it as a 'Zen Farce', Buddhist motifs appear. Midori Yoshimoto has pointed to an influence from *The Holy Man of Mount Kōya* by the Japanese writer Izumi Kyōka. The protagonist in Kyōka's story is tested via an encounter with an attractive woman who turns out to be a serpent-demon; in *The Gorilla Lady Meets the Demons of Change*, Kusama's character is presented as a sacrificial victim to a phallic snake. Kusama's own 'white phallic sculptures' would be part of the stage set. The script was submitted to a Broadway production company – and rejected.

That Kusama's work should have taken a theatrical turn reflected her enduring interest in the stage. She regularly went to see plays: Arthur Miller pieces, an adaptation of Dostoevsky's *The Idiot* and performances at Greenwich Village 'beatnik dives' were among the shows she remembered seeing. She was impressed by Alan Jay Lerner and André Previn's musical about the fashion designer Coco Chanel, which starred Katharine Hepburn, and went to see a septuagenarian Gloria Swanson in Leonard Gershe's *Butterflies Are Free* at the Booth Theatre.

Swanson, one of the biggest film stars of the Silent Age, had made a memorable return to the silver screen as Norma

Desmond in *Sunset Boulevard* (1950). Kusama wrote that she was inspired by Swanson's 'die-hard thespian spirit'. It is not hard to see why: the artist had shown a similar spirit of tireless self-reinvention and performative vigour throughout her time in New York. With the turn into a new decade and Happenings becoming less happening, Kusama would need to demonstrate the same qualities again.

9

The Return to Japan

After more than a dozen years' absence, Kusama decided to carry the 'nude revolution' back to her native land. She had arrived in Tokyo at Haneda Airport on a Northwest Airlines flight on the evening of 6 March 1970, primed to 'blow away the sexually constipated Japanese'. It was the first time she had set foot in the country since November 1957; struck by the degree to which Japan was 'still a man's world' and horrified that men 'were still throwing their weight around', she found herself wanting to take a baseball bat and beat them. Castration was in order. She hoped to persuade Japanese women to remove their underwear and set it alight, as had happened at a Burn the Panties Happening in New York.

It was an opportune moment to start a revolution: Expo '70, the first world's fair to be held in Japan, was about to open in Osaka, so the eyes of the world were turned on the country. 'Day after day, night after night, I was caught in a whirl of media events,' Kusama remembered. She took up position in front of the Nijubashi Bridge next to the Imperial Palace in Tokyo, removed her tights and asked the attendant photographers of the press to snap one of the most famous constructions in Japan framed by her legs. She had wanted to stage a 'Homo Parade' for the opening in Osaka, and

a climactic 'Nude Panorama' in front of the National Diet building in Tokyo. But reactionary Japan – despite Expo '70 promising 'Progress and Harmony for Mankind' – proved less receptive to the peace-and-love aesthetic than the US.

An attempt to *épater le bourgeois* by stripping on morning TV on 12 March was frustrated when, according to the news source *Shukan Bunshun*, the announcer stepped between Kusama's naked form and the camera. The following day she was arrested after giving the order to three female collaborators to take off their coats and reveal their naked breasts as part of a 'Midnight Happening Show' in Ginza, one of the most elegant districts in Tokyo. Kusama had pre-painted their torsos with polka dots, but as she urged them to 'Go wild!' they were arrested and taken to a station in Tsukiji.

In New York, Kusama insisted, a few banknotes had always been sufficient to secure the release of herself and her performers, but in Tokyo an attempt at bribery failed as the police officers tried to get the women to take off their coats again so that they could see their breasts. Everyone kept their clothes on for a subsequent TV appearance in which Kusama presented her fashion designs. The programme was followed by a Kusama-directed parade in the Akasaka district of Tokyo where the models wore clothes made from Soviet flags.

Disappointed by the prurience of the coverage she was attracting, by mid-April Kusama could take no more. Japan was, she said, a 'corrupt and bogus, fourth-class country'. She had wanted to 'tear down the barriers between Self and Other' by means of a free love revolution, but the media and public response had been sordid. 'Ruminating that ever

since the days of Jesus Christ, no revolutionary has ever been welcome at home,' Kusama said, 'I left Japan behind once again.'

Afterwards, Kusama set up base in Rome as part of an extended European jaunt during which she staged fashion and body-painting performances and showed her *Cage Paintings* at the Internationale Galerij Orez. Her star was waning, however. As Laura Hoptman has noted, 'her archives reveal that not a single word was written about [her]' in 1971. In November of that year, *Kusama's Self-Obliteration* and *Flower Orgy* were screened at the First Annual New York Erotic Film Festival. The following year, her address was given in *Who's Who in America* – Kusama was proud to be included in the publication for the first time – as the legendary New York bohemian hangout the Chelsea Hotel, where Warhol had shot *Chelsea Girls*, his 1966 film portrait of the lives of the Factory super-stars. Not that Kusama appears to have stayed there long; she set up a studio on St Mark's Place on the Lower East Side that would serve as the home of a new venture: the Yayoi Kusama Art Import Co.

Then, in 1973, she returned to Japan. Initially it was intended to be a temporary stay, but events would conspire to make Tokyo her permanent home.

At the time, Kusama's motives for returning to her native land were mixed. She needed to have surgery on her foot, she said, and she also wanted to set up her art import company there. There was a real opportunity to make some money, she thought. Japan was booming economically, and Kusama imagined herself operating as an agent to furnish works

to wealthy Japanese buyers who coveted owning a major piece of Western art or two. She set about building a relationship with the highly successful New York art dealership of Wildenstein & Co., and was able to exploit her fame – and perhaps infamy – as an artist to build relationships with collectors in Japan. The well-known publication *Shūkan Shinchō* was keen to give coverage to this new venture.

Joseph Cornell died on 29 December 1972. Kusama's correspondence with Udo Kultermann at this time sheds some light on her feelings about his passing. She and Cornell had shared '10 years of friendship', she told Kultermann – in her autobiography she would conclude: 'Ours was a platonic love, a pure and sacred kind of bond' – and not a single day had passed when Cornell 'did not call me talking several hours on telephone'. They had remained very close and might even have lived together: they had discussed the possibility of moving in together in the spring, she said. Cornell had not wanted her to go to Japan, and was against her working as a dealer too – he wanted her to focus on making her own work, not on selling that of others, although he had nonetheless said that he would allow her to sell his work.

Kusama operated her business initially from a room in the Imperial Hotel in Tokyo and was able to report to Kultermann that she was doing very well owing to the 'great art boom in Japan'. 'I am handling only the masterpieces,' she told her old friend. At the end of the year, she told Louis Goldenberg of Wildenstein & Co. that she was forging ahead, but had reached 'only 70%' of the '1 million dollar business goal' she had targeted. In June 1974, she thanked her

friend Henk Peeters, who had done so much to further her career in Europe, for sending her a piece by Piero Manzoni, who was notorious for his *Artist's Shit* canned works. She mentioned 'about 20 million dollars worth' of 'Barbizon style paintings' that she had just obtained from England too. The business was thriving, then, and she seemed to be spending a lot of time on flights between America, Europe and Japan to support her dealings. But the market would soon get tougher as a result of the 1973 oil crisis.

Although she was now relieved to be back in Japan, Kusama felt alienated from many of the people there. 'I was struck by their lack of individuality...Their lifestyles and their ways of thinking had all become uniform,' she recounted. And as a creative force she remained misunderstood. 'Even if I am in my own country,' she told Kultermann, the art world nonetheless left her with 'a feeling of loneliness'; she estimated that it would be several decades after her death before the major Japanese institutions finally understood her 'obsessional work'. Her darkening mood is reflected in the work she was making at the time, including ceramics such as *Entrance to Hell* and *The Hate I Wore When I Was Alive*.

Kusama's father died in June 1974, and she participated in the Obon annual festival honouring the spirits of the family's ancestors. She returned to visit Matsumoto and, though she still found it a magical place of 'heart-stopping beauty', was depressed to find it now '[c]orrupted by civilisation'. 'New roads had encroached half-way up the once majestic mountains, leaving them painfully bare and scarred,' she reported. During her long absence overseas, her reputation had been tarnished by 'falsehoods and gossip'

that had circulated about her activities in New York, and she described various Japanese visitors to her studio as 'scum' who had spread false stories about her and stolen her work.

Distressed by what she had been told of her younger daughter's exploits, her mother had visited the family cemetery to ask their ancestors for forgiveness for the shame she had brought on them, and afterwards had expressed a wish that Yayoi had died when she had a bad throat infection as a small child. The Japanese press had variously labelled her 'The Queen of Scandal', 'The Shameless Artist' and 'The Naked Provocateur', and Yayoi was sad to discover that her name had consequently been erased from the membership list of the Matsumoto First Girls' High School Alumnae Association.

In 1975, with both her professional and her personal life at a nadir, the magazine *Geijutsu Seikatsu* (*Art Life*) published Kusama's essay 'The Struggle and Wanderings of my Soul', a response to her critics that attempted to explain her need to escape the constraints of her 'feudalistic old family [that] was still sticking to the stereotype that "painters and actors belong in the same category as beggars"'. It recounted the hallucinations she had had as a child and that drove her 'obsessional art'. She had begun to make work, Kusama explained in the essay, 'to correct the disability which began in my childhood'. It had 'started from something primitive and instinctive, far removed from art' – the need to protect herself from suicidal despair.

Kusama had moved into a tenth-floor apartment in the Shinjuku district of Tokyo that overlooked a cemetery. But experiencing hallucinations and suffering from the kind of despair evoked in 'The Struggle and Wanderings of my Soul', she was hospitalized. Dr Yoshihito Tokuda,

of the Japanese Society of Psychopathology of Expression and Arts Therapy, was responsible for her care.

There were solo exhibitions. *Message of Death from Hades* at the Nishimura Gallery in Tokyo in December 1975 appears to have been Kusama's attempt to deal with her feelings about the loss of her father and Joseph Cornell. Indeed, Kusama claimed to have recycled material Cornell gave her in the 35 collages featured in the show. Among the visitors was the curator and poet Akira Tatehata. Kusama was present at the time, but he found her frightening and did not approach her. He was bowled over by her work, however. 'It was then that I made it my curator's mission to have society rediscover this genius,' he said; the coming years would see him fulfil his resolution.

Kusama was hospitalized again before *Obsessional Art: A Requiem for Death and Life* opened at the Osaka Formes Gallery in Tokyo in August 1976. At the end of the year, as a former Brata Gallery artist, she was invited to participate in *Tenth Street Days: The Co-ops of the 50s* in New York, but the need to undergo an operation may have prevented her from travelling to the US in person.

Then, in early 1977, came a great and lasting change: Kusama decided to make the hospital in Shinjuku her permanent home. Not that this would stop her from making work. Quite the opposite; the move would facilitate her practice. She set up a studio in the medical facility, while reserving a space nearby for storage and other purposes. In retreating from the world in this way, Kusama was determined to make a new beginning.

10

'A Lyrical Frame of Mind'

Resuming a childhood passion, Kusama had begun to write verse and fiction again.

In a conversation with the artist first published in 2000, the curator Akira Tatehata pointed to an important general difference between the work Kusama had produced in New York and the work she made in Japan both before and after her US adventure. The former, he said, 'feels drier and more inorganic', while the latter was 'more literary'. Kusama agreed. 'In Japan, I write poetry,' she said. 'In New York, there was no mood for poetry; every day was a struggle with the outside world.' The US was not a place where one could 'live with a lyrical frame of mind', she said, and this was evident in the work she made there.

A renewed lyricism, albeit of a darkly subversive and transgressive kind, flooded through Kusama as she lay in her bed in hospital after her return to Japan. She had enjoyed writing stories and poems as a child, and she did so again now. The process, she said, involved 'meeting up again' with her native language.

Across the course of the next 25 years or so, Kusama would publish more than a dozen works of fiction, a collection of poems and a volume of autobiography. The novelist Ryū Murakami compared her fictions to those of Jean

Genet: both writers, he said, 'make filth shine'. Kusama's stories, set for the most part in New York or Japan, revolve around an underground world of semi-autobiographical characters operating at society's margins. Hallucination, graphic sex, violence, addiction, prostitution, mental illness and suicide are narrative touchstones in fictions that are at once transgressively abject and poetically transcendent. For her, Kusama explained, writing, like art, was a therapeutic activity, a means to express 'the negative feelings inside of me, human pain, life and death'.

* * * * *

Kusama's first book, *Manhattan Suicide Addict*, was put out by the small publisher Kōsakusha in March 1978. There was a foreword by Sir Herbert Read and an afterword by Shūzō Takiguchi, the Surrealist poet and critic who had written a text for her second Matsumoto show in 1952. Entitled 'My Nymph through Eternity', it recounted their friendship and represented a heartfelt compliment to Kusama 'Lingering in the crevices of illusion, the interstices of a vast void'.

'I dashed out the novel itself in three weeks, in a burst of manic energy,' Kusama said, 'and it was published without any alterations.' *Manhattan Suicide Addict* has something of a mixed status, being described variously as a novel (as here by Kusama) and as a 'faux autobiography'. The narrator, identified as Kusama herself, relates her career as an artist and organizer of Happenings in New York after quitting her native Japan. When a French edition was published in 2005 by Les Presses du Réel, the text was preceded by a new

interview with the author. In it, Kusama is asked about the book's contents, including its descriptions of drug use, from marijuana to heroin, and of multiple orgies. 'You told me that it was all true,' says the interviewer, Franck Gautherot, to which Kusama responds, 'Yes, it is all true.'

If that is the case, the book exemplifies a very particular kind of truth: incidents are recalled with apparent precision, people are named and events are exactly dated – the book is also illustrated with photographs of Kusama's paintings and Happenings from the 1960s, including one taken at Warhol's Factory – but the reality described is hallucinatory. It is a delirious memoir, a hybrid account of Kusama's artistic experience in New York containing many, many exclamation marks. The highly persuasive details of running a business vie with vivid dream-like evocations of Happenings; cosmic poetry rubs shoulders with enraged naming-and-shaming of real-world collaborators.

The narrator returns several times to the 'curtain of depersonalization', a manifestation of her mental illness, through which she views the world. This began in childhood, with a revelation of her 'destiny'. It has been 'a meaningless obsession, since I saw it in the form of lichen patterns on the concrete wall of the sports ground in the primary school of my native region'. The pattern has repeated itself since childhood as a white curtain hanging before Kusama. Is there a penis hidden behind it? she asks. Kusama has been an outsider since birth, her Japanese childhood an 'opaque scar', her youth there 'humiliation and nothing else'. There are memories of childhood behaviour perceived as both deviant and defiant, such as peeing from a bridge on to the

little boys fishing underneath. As a girl, she has a violent fantasy of being run over by a train and dismembered; later on, she experiences a vivid fantasy of rapid ageing and turning into a decomposing old woman hearing the peal of the bells of the temples in Gion, which ring 108 times at midnight on 1 January according to Japanese Buddhist tradition. During her time in New York, the exiled artist becomes 'a vagabond wandering between reality and unreality' with the help of sleeping pills and heroin, producing a constant, semi-awake Sleeping Beauty state of consciousness.

Kusama identifies her first Happening as the experience of having measles as a child and seeing her body covered in red spots – a premonition of the polka dots that would colonize her artworks. The illness, she says, confirmed that she was alive and also, crucially, meant that she could stay away from school, so allowing her to dodge the morality lessons taught there under the directions of the imperial government. Kusama's mother was descended from a Samurai commander and, in common with her (debauched, hypocritical) father, had a fear of dishonour and loss of face and an extreme adherence to archaic formality even 'in the age of Coca-Cola and jet planes'. *Manhattan Suicide Addict* has Kusama running away from familial and cultural strictures: an arranged marriage is on the cards, but instead she leaves for the 'unsettling land of the *So What*' with the money set aside for her dowry tucked in her underwear and the lining of her coat. 'I changed my destiny,' she says. Away from Japan and her traditional, dysfunctional family, she becomes, as she describes herself, a vagabond, pimp, an art delinquent – 'the female beast making a racket', 'a hysterical witch', a 'pedlar' of gay men – reviled in the Japanese press.

The business she set up, Kusama Enterprises, was at once a 'modest family' affair (her entourage of boys is her family) and 'the Church of Polka Dots', where you can be enlightened by Kusama. The cosmic sex parties are described as 'musical comedies' and are attended by establishment figures such as professors, lawyers and pastors, not to mention a drugged-up dog named President Washington, real or imaginary policemen who come to stop but end up joining the orgy, and Kusama herself as a nude Christ being carried aloft by gay men wrapped in the American flag. She mentions that she began to stage them before *Hair* was first produced, and before John Lennon and Yoko Ono's nude activism.

In the 2005 French edition, the interviewer asks Kusama about *Manhattan Suicide Addict*'s erasure of all the female participants in her Happenings. Women had performed in the real ones she staged, but in the book these female participants are largely absent. Kusama replies obliquely that New York offered her a plentiful supply of young gay men she could hire for her orgies. In *Manhattan Suicide Addict*, there is a determined focus on male homosexuality, which Kusama sees as a major currency in the New York art world. In New York, she says, even the cats are gay. So she becomes 'Pimp Kusama', employing young gay men not only as participants in filmed Happenings but also as prostitutes (rented out to men but also to society women), and storing the dollar bills that she earns in her tights.

Obliteration is at the heart of the sex parties staged by Kusama, during which she wanders, cross-dressed as a Japanese boy, painting participants' bodies, including their penises, and daubing pubic hair with purple and green.

The penis is a problematic object: even with her sculptor's gaze, whatever her line of sight, she 'can't make out any sculptural form'. There are riffs about America's mad 'violence of the dick', linked to capitalism, and the 'hysteria of dicks' expressed in the conflict in Vietnam and generally through warfare. There is also a melancholy image of a demoralized penis staring out of the window at a disenchanted landscape.

Kusama's revulsion for birth (especially her own – she was a 'bad bud') causes her to call for an end to reproduction and heterosexual sex. There is something existential and apocalyptic about this obsession. The solution to the nightmare of overpopulation, she says, is the staging of a large-scale orgy festival that should continue 'until the semen-making machine breaks down'. Semen, an American-inflected 'milk-coloured soda', flows during the Happenings, its supply seemingly endless. Another Kusama conceit is to harvest the industrial quantities of semen produced in the orgies and turn it into tinned goods.

The book is haunted by dreams of suicide, the artist's liminal state of consciousness serving as a sort of halfway house to death. She is tempted to commit suicide on stage during a Happening; elsewhere, the iconic Empire State Building – a phallic structure – is identified as a suitable spot from which to plunge to one's death. Kusama speaks of her engagement with the New York art world as 'serial suicide'; it is in part in this sense that she is a 'suicide addict'.

While she does mention some rich collectors buying her work, she suggests that the various Kusama business enterprises were more lucrative. Although she was in New York at the time of the 10th Street action painting scene,

she refused to align herself with it. Constantly undermined and misrepresented by the Japanese art establishment and an outsider in the superficial US art world, Kusama ploughs her own furrow. She is savvy and hard-nosed, relying on a New Jersey gangster, who drives around in a Rolls-Royce, for the financing of her *Kusama Orgy* publication, for instance. The gangster's printworks are, she says, a cover for his drugs business. Meanwhile, there is nothing in museums but dead art: a mountain made up of the corpses of masterpieces. Instead, she says: 'One should build a museum into which would fit the Earth, which I have covered with polka dots.' Later she says of her name: '*Kusama*: that is, signing the earth.'

* * * * *

Although writing was occupying a good deal of her time, the indefatigable Kusama was still staging shows and, in common with her literary endeavours, her art was taking a more lyrical turn. She had recently become interested in making ceramics and, under the influence of Tokuzo Okabe, she now also began to produce prints.

Kusama made a notable return to her home city of Matsumoto in 1978, when she was given an exhibition at the Municipal Hall of Commerce and Industry, her first at the venue in over a quarter of a century. Solo shows followed thick and fast in 1980, not least one at the American Center in Tokyo in May–June 1980, which featured a screening of her 1968 film *Kusama's Self-Obliteration*. But perhaps the most important sign that the Japanese art world was ready

to welcome her back into the fold was the inclusion of five large-scale works by her in *The 1960s: A Decade of Change in Contemporary Japanese Art* at the National Museum of Modern Art in Tokyo the following year. The Italian Academy of Arts also awarded her the Golden Prize.

In early 1983, Kusama made her debut at Tokyo's Fuji Television Gallery, which would prove an important connection as she rebuilt her career across the coming decade. Mixing together large paintings and protrusion-covered objects from her New York period with more recent works, this semi-retrospective, her eleventh exhibition in Japan since her return, was both bigger and better publicized than her previous outings. There was a preview on Fuji Television's Sunday morning art show, and reviews of the exhibition in both the specialist and the mainstream press.

* * * * *

Five years after its first publication, in 1983 *Manhattan Suicide Addict* was reissued in paperback. In the same year, *Hustlers Grotto of Christopher Street*, Kusama's second work of fiction, was published. As a result of this collection of stories winning *Yasei Jidai* (*Wild Times*) magazine's prestigious Tenth Literary Award for New Writers, Kusama's fame as an author briefly eclipsed her renown as a visual artist.

The book's preoccupations are characteristic. The titular tale is centred on Yanni, a former philosophy student who now runs a male prostitution business in Manhattan called the 'Paranoiac Club'. Yanni grew up in Hong Kong, where she lost her virginity to her father. Her heart being 'so full

of hatred for men', she now relishes her role, which involves selling young men 'casually, as if they were cakes wrapped in pretty paper and tied with ribbons'.

One of her own prostitutes, an African-American drug addict named Henry, is an occasional sexual partner for Yanni. She now sends him off with a wealthy client named Robert Greenberg, who takes him to his New Jersey home and rapes him. Henry's 'sex drive decreased daily', we are told, 'in inverse proportion to his growing need [for drugs]'. Robert seeks love or at least feeling, which strikes Henry as absurd: 'A sexual pervert and a dealer in perverted sex who pretended to be perverted lay one atop the other in bed, probing each other's hearts, negotiating over an anal cavity.' Yanni's prostitutes in general show little interest in engaging in profound conversations or 'talking rot about homosexual art': 'For them it was take the money, here's my asshole, see you later.'

Suffering terrible drug withdrawal symptoms, Henry hallucinates and cuts off Robert's penis. He then flees with Yanni to the top of the Empire State Building, which is engulfed in mist. Overcome by 'a thin translucent curtain cutting him off from the external world…leaving him a prisoner behind the curtain of depersonalization', he commits suicide and disappears into the white oblivion.

There are recurrent themes here. As revealed in *Manhattan Suicide Addict*, Kusama had considered throwing herself off that great midtown New York City phallic symbol, the Empire State Building. In her fictions, as Alexandra Munroe has noted, Kusama repeatedly 'describes the lives of misfit females whose spectacular obsessions with

phallocentric animism are the conduit for transcendence into another world', as, for instance, in *Between Heaven and Earth* (1988). In another work of the same year, her fifth graphic work of fiction, *Woodstock Phallus Cutter* (1988), she tells of ten-year-old Emily, who is raped by her father, an artist and teacher at the Art Students League in New York, where Kusama herself had enrolled in the late 1950s, and also has sex with her brother. On one occasion, while having sex with her father, Emily undergoes a fit of depersonalization and scissors off his penis. She becomes fixated on gathering up male members and tries to lay her hands on a doctor's collection of 456 penises by castrating its owner. By the time Kusama was writing her fiction, the 'Sada Abe panic', which scandalized Japan in her childhood and to which Kusama alluded in a statement of c. 1966–67 in regard to her phallic sculptures, had been turned into a film, Nagisa Oshima's *In the Realm of the Senses*.

The prize jury for the *Yasei Jidai* award included representatives of a new generation of novelists such as Kenji Nakagami and Ryū Murakami, who were strongly influenced by the decadent gothic fiction of Kusama's own favourite Japanese writer, Izumi Kyōka (1873–1939), whose works shared strong, fantastical elements of occult violence and eroticism with Kusama's. Kusama would establish lasting ties with Nakagami and Murakami; indeed, her friendship with the latter led to her appearance in his 1992 Japanese 'pink' (erotic) film *Topaz* (aka *Tokyo Decadence*) about a prostitute named Ai who, among other things, is drawn into a series of S&M scenarios. Kusama plays a fortune-teller. (In 1989, Kusama worked on several issues of the magazine

S&M Sniper in collaboration with the Japanese photographer Nobuyoshi Araki.)

Kusama's mother, Shigeru, died in December 1983, still unconvinced at the age of 78 that her daughter had made a wise decision in choosing to become an artist rather than taking a more conventional path in life. Although still conflicted in her feelings towards her parents, Kusama would later express her 'heartfelt gratitude and the greatest love and respect' to them. Movingly, in a postscript to her novel *Double Suicide at Sakuragazuka*, a tale revolving around teenage pregnancy and the tyranny of Japanese society, she would include three pieces of verse by her mother, a talented poet and calligrapher. This tribute was published in 1989. Had her mother lived to witness the events of that year and their impact across the coming decade, she might at last have accepted that her daughter's career choice was finally beginning to pay off.

11

The Kusama Renaissance

Now a permanent resident in the hospital in Tokyo, Yayoi Kusama turned 60 in March 1989. Sixtieth birthdays in Japan are special and are celebrated as *kanreki*, when one cycle of life is at an end and another is about to begin. This was certainly true in Kusama's case, as her career underwent a major international rebirth following the opening of the first significant US retrospective of her work.

Curated by Alexandra Munroe, *Yayoi Kusama: A Retrospective* was both the inaugural show at the new Center for International Contemporary Arts (CICA) in New York and the first major critical survey of Kusama's work outside Japan. It presented her varied output from her early years in Japan and the New York years – Infinity Net paintings, Accumulation sculptures, room installations and Happenings – and re-established her as an artist of international importance.

As Munroe commented, at the time Kusama was selected as the subject of the CICA's inaugural exhibition, she was a cult figure, fondly remembered and even revered by artist peers such as Donald Judd, but whose activities and innovations were otherwise quite forgotten in the US. The point was not lost on the art critic Roberta Smith, who, in reviewing the

show for the *New York Times*, noted that, though the 1960s were not very distant in time, they were already sufficiently out of mind for important gaps to have developed in the current generation of artists' and commentators' memory of them. Kusama's work was both highly characteristic of those times and strikingly independent. 'Her art touches on Pop Art, Minimalism and Surrealism as well as the European Group Zero,' Smith wrote, 'but it also reflects a distinct, obsessive and often sexually charged sensibility that can be traced to her childhood. Her work is both pure and polymorphously perverse, intuitively systematic and a little mad; relentless repetition is its most characteristic strategy.'

The exhibition ran from September 1989 to January 1990. Kusama attended the opening. It was the first time she had set foot in New York for 16 years. She found it much changed – much declined. The Big Apple had begun to rot, she said, but she still considered its support for culture and the arts 'at least ten times what it was back home' in Japan. The launch of the show had had to be put back, Kusama noted, because the CICA wanted to carry out thorough research and she had been 'an incorrigible squirrel' – that is, she had extensive archives that the museum was keen to go through. Munroe remembered being stopped at customs with the Kusama material in her possession and having to explain to sceptical officials that it was art history and not pornography.

Afterwards, Kusama complained that she 'disagreed' with some of what the CICA subsequently included in its catalogue, but the publication was an important stepping stone. Munroe's catalogue essay, 'Obsession, Fantasy and Outrage:

The Art of Yayoi Kusama', laid an enduring framework for the interpretation of her oeuvre – Munroe declared Kusama an original: 'The art world is her costume trunk: She grabs what strikes her fancy, shoves aside what bores her, wears styles in unheard of ways' – while the accompanying biographical and bibliographical materials, compiled by Reiko Tomii, provided a vital resource to researchers interested in Kusama's activities in Japan, the US and Europe from birth to 1989.

Among other things, Munroe argued for the importance of including non-Western artists in accounts of the international avant-garde. As she later remembered: 'It was just weeks before the fall of the Berlin Wall heralded a newly global world, and the time was right for a rigorous reappraisal of modern Euro-centric and gender-biased art history that integrated Kusama's work into a more expansive view of postwar and contemporary culture.' In a sign of a shift that was under way in the wider art world, the exhibition helped secure Kusama a cover story in *Art in America* – she was the first Japanese artist to be featured with such prominence in the influential US art-world publication.

* * * * *

The CICA show may have been critical in restoring Kusama's reputation outside Japan, but there were stirrings of interest elsewhere simultaneously. The same year also saw *In Context: Yayoi Kusama, Soul Burning Flashes* open at the Museum of Modern Art in Oxford, while *Japanese Ways, Western Means* at the Queensland Art Gallery, Brisbane, marked

Kusama's Australian debut. Internationally, the Kusama Renaissance was under way.

In Japan, Kusama had been making steady progress in resurrecting her profile since the personal and professional nadir of the mid-1970s. The catalogue to the CICA show acknowledged as much. 'She is still given to bouts of deep depression, fits of rage and reckless exaggerations,' it noted, but pointed out that she was making 'an increasingly comfortable living' in Japan, where she was producing material 'at a prodigious rate'. Her attitude to work had changed little since her New York days. Of the 20 artists represented by the Fuji Television Gallery – 'approximate annual turnover of $40 million' – it noted that she was the only one 'who appears at the gallery's accounting office on the first day of each month to check on what is due to her and to get paid, just like any other laborer. And she labors hard.'

That hard labour is reflected in an extraordinarily busy itinerary of shows across the previous decade. In the early 1980s, Kusama had made a return to painting and sculpture. Net and dot motifs were regularly featured in a manner that suggested continuity with her 1960s New York manner. But an evolution was taking place, as she began to use acrylic in all-over compositions and to paint forms in a more standardized, stencil-like fashion. Biomorphic, increasingly tentacular forms germinated. She began to make box-like sculptural constructions, the compartments stuffed with signature elements. The familiar phallic forms were becoming elongated, suggesting writhing snake-like sea creatures. As Bhupendra Karia noted, in around 1988

a new motif appeared: 'a sperm-like form sprouting polka dots or eggs hatching into tadpoles.'

Kusama was still interested in putting on Happenings, although the event she staged on 9 April 1985 was very different in terms of content and tone from the work she had made in New York in the 1980s, or in Japan on her first return in 1970. *Flowers of Extravagance* took place in the cherry orchard in the grounds of Kuhonbutsu Jōshin-ji temple in Tokyo. It was designed to commemorate a legendary feast at the Shōji-ji temple near Kyoto organized by the 14th-century *daimyō*, or lord, Dōyo Sasaki, to celebrate the cherry blossoms. Kusama's recreation was staged at the invitation of Tadashi Yokoyama, an associate architecture professor at Tokyo University, and involved symbolically binding together the blossoming cherry trees in the temple's grounds in lengths of red and white plastic tape.

Kusama's prints were the focus of a show at the Takashimaya department store in Tamagawa, Tokyo, in March 1986, while a few months later her stuffed protrusions and box sculptures served as the subject of *Infinity Explosion* at the Fuji Television Gallery in Tokyo. There was international exposure in group shows in Taipei and San Diego and at the Pompidou Centre in Paris.

The following year, Kusama was given her first major retrospective, at the Kitakyūshū Municipal Museum of Art in Fukuoka. Opening in March 1987, as she turned 58, the show featured 79 works drawn from across a nearly 40-year period, beginning in 1948. The works – watercolours, collages, sculptures – were selected by Kusama herself. Meanwhile, another solo exhibition, of recent three-dimensional works,

was travelling across France, from the Musée des Beaux-Arts in Calais to the Musée Municipal in Dole, while inclusion in group exhibitions increased Kusama's visibility in other countries, including Austria.

The Fuji Television Gallery in Tokyo had become her primary dealer. In June 1988, *Soul Burning Flashes* opened featuring ten large three-dimensional works and 13 paintings. The canvases were becoming more lyrical and growing in complexity; they also contained more unfilled space, as the CICA catalogue pointed out. 'Somewhere in the deeper recesses of her soul she seemed to have made a connection with the literal meaning of her full name: The space between blades of spring grass (Yayoi = the third month, or spring, and Kusama = between the grass).'

* * * * *

In 1993, Kusama returned to the Venice Biennale, this time not in a semi-guerrilla capacity but rather as a fully official participant. Not only was she the first female artist to represent Japan, she was the first Japanese artist to be given a solo exhibition at the Biennale. It was Akira Tatehata, the commissioner of the Japanese Pavilion and a loyal supporter of Kusama who had first seen her work in 1975, who convinced the Japanese authorities that she should be honoured in this way. In his catalogue essay, Tatehata called Kusama a 'heretical' figure and noted that her 'lonely achievement' had been 'the object of much prejudice and misunderstanding'. Thanks to the Venice installation, this prejudice and confusion would begin to be cleared away.

Although concerned enough about her mental wellbeing to be accompanied on the trip by a psychiatrist, who slept in the hotel room next to hers, a fragile-looking Kusama attended the Biennale launch and, as on her first Venice appearance, made quite an impression. In 1966, she had worn a gold kimono and distributed mirrored balls; this time she appeared at the launch dressed in a yellow-and-black polka-dotted pointed hat and robe and handed out similarly decorated miniature pumpkins to attendees.

The exhibition was an extraordinary success and took the form of a mini-retrospective. Early Infinity Nets, Kusama's first sculpture, *Accumulation No. 1*, and *My Flower Bed* from 1964 were paired with more recent paintings and box sculptures. There were two rowing boats, one in bright pink, the second multi-coloured and covered in polka dots. The centrepiece was the *Mirror Room (Pumpkin)*, a large space decorated with a yellow and black polka-dot pattern in the middle of which sat a room-sized box mirrored both inside and outside, akin to that featured in the 1966 *Peep Show* at the Castellane Gallery in New York. It was punctured with a single viewing window through which spectators could look in and spy what seemed to be an endless expanse of papier-mâché pumpkins, covered in the same yellow and black polka-dot pattern as the surrounding gallery. The effect resembled the 1965 *Infinity Mirror Room*, also seen at the Castellane Gallery.

Kusama was continuing to produce many pieces of the kind she had been making in the 1960s. In 1991, she conducted a Self-Obliteration performance in Ginza, Tokyo, where she covered both spectators and surroundings

in polka dots. Repetition and accumulation were still at the core of her practice, but the scale was growing and a new vocabulary of forms was emerging. The flat, graphic look of some of this work seemed to draw energy from the 'cute' or *kawaii* aesthetic of Japanese manga and anime. (Not that Kusama was keen on being associated with that particular look. 'I am not happy being put in that *kawaii* category,' she told an interviewer in 2012. 'If I do something that is considered to be like that, I want to scratch it out.')

Dots – which had been such an important part of her practice, even at the height of her anti-war campaigning – dominated the field in a number of new works. The first of Kusama's *Dots Obsession* installations of large balloons appeared at her 1996 show at the Mattress Factory in Pittsburgh. This consisted of a room filled with large, vaguely anthropomorphic latex balloons; walls and inflatables were both decorated in black polka dots on a yellow field. A second installation, *Repetitive Vision*, in which red dots covered a white floor and a series of mannequins, was designed to evoke the hallucinations she had had as a child.

Kusama had begun working with Ota Fine Arts in Tokyo, and her new work was increasingly winning plaudits. At some point in the mid-1990s, in terms of international perception Kusama arguably went from being an artist of mostly historical interest to being recognized as a contemporary creative force again. Her New York solo exhibitions at Paula Cooper (showing old works) and Robert Miller (showing recent works) scooped the International Association of Art Critics 'Best Gallery Show' awards for 1995–6 and 1996–7 respectively. 'Her accumulating technique has enabled her

to flit among media and cultures with the greatest of ease, mixing East and West, insider and outsider in the process,' Roberta Smith wrote of the Cooper show in the *New York Times*. There was also an appearance on the cover of the commercial art-world bible *Artforum* in 1997.

A new summit in terms of popular and critical recognition internationally was attained in the final years of the millennium. In 1998, Kusama had more than 30 exhibitions worldwide, from London and Paris to New York and Tokyo. Perhaps the most influential of these was the major retrospective *Love Forever: Yayoi Kusama, 1958–1968*, which opened at the Los Angeles County Museum of Art in 1998, before moving on to MoMA in New York and the Walker Art Center in Minneapolis, and finally travelling on to the Museum of Contemporary Art in Tokyo in April 1999. The LACMA show again focused on Kusama's hyperproductive New York years, but in Tokyo it was joined by *In Full Bloom: Yayoi Kusama, Years in Japan*, which surveyed work made both prior to her departure for Seattle in 1957 and since her return to Japan, from the 1970s to 1999. These shows initiated a new critical engagement with her work, presenting an opportunity to see Kusama's career in the round; to grasp its continuities and sudden evolutions, and to establish definitively that it was still very much a work in progress.

A show at the Robert Miller gallery ran concurrently with *Love Forever* in New York. It featured ten life-size reproductions of the *Venus de Milo* arranged in a circle, which vanished into veils of pink nets that also covered the gallery walls. In an interview with Damien Hirst published in the accompanying catalogue, Kusama described her life.

Time was precious, so she no longer went out or attended other artists' shows. 'I try to avoid seeing people. I don't attend art-related meetings. I am lonelier now.' When she found herself at the top of a tall building, she still felt an urge to jump. But, as it had before, art saved her from acting on her impulse. 'My passion for art is what has prevented me from doing that.'

To coincide with *Love Forever* and *In Bloom*'s run in Tokyo, the philosopher and curator Akira Asada wrote an essay celebrating Kusama's achievement. The artist was obviously moved by Asada's tribute to her 'bitter struggle' and indomitable spirit in fighting 'a touch-and-go battle with death', since she quoted it at length in her autobiography. Asada points to collages such as *Spirit Going Back to its Home* and *Now That You Died*, made around the time she was hospitalized in Tokyo, which 'had a febrile naivete about them that pierced the viewer's heart and caused him to wonder if the artist hadn't lost the power to go on living'. It was as a result of that that he could not stop himself from uttering 'a cry of astonishment at the overpowering explosion that followed'. Kusama had 'turned the tables on a life-threatening repetition compulsion, converting it into art and attempting thereby to effect a self-cure'. The work had 'gone far beyond the level of mere self-healing'. Appropriately, the piece was entitled 'The Victory of Yayoi Kusama'.

12

The Ultimate Victory
of Yayoi Kusama

Filmmaker Heather Lenz began work on a full-length documentary about Yayoi Kusama in 2001. *Kusama – Infinity* was finally released in 2018, when Lenz would joke, 'Ironically I thought the film was going to bring her greater success.' By that time, as the director acknowledged, that was hardly possible. The Kusama Renaissance had long since turned into full-on Kusamamania.

Akira Asada's 'The Victory of Yayoi Kusama' had painted a portrait of a lonely artist, 'a mass of wounds', who had largely renounced personal relationships and who 'lives on in righteous solitude'. Kusama's autobiography, *Infinity Net*, published in Japan in 2002, offered a similar view of her existence as she entered her eighth decade. 'Life in the hospital follows a fixed schedule,' she reported. Up at seven in the morning for a blood test; off to the studio at ten; work until six or seven; write in the evening. Repeat. As a result of this highly disciplined routine, she remained 'extremely prolific', although it left her 'always exhausted'. Acupuncture, moxibustion and massage formed components of her health regimen, in addition to a daily walk to the nearby district of Kagurazaka – 'a thousand steps'.

Kusama used the book to express her gratitude to the US. 'America is really the country that raised me, and I owe what I have become to her,' she noted. Her feelings about Japan remained ambivalent. She remembered returning from New York in the 1970s 'to find that my country seemed a good hundred years behind the times'. The economic bubble of the 1980s had generated a great deal of wealth, but the profits had been 'wasted on all sorts of frivolities'. Even now, at the beginning of the new millennium, she wrote, contemporary art 'has yet to fully blossom here'.

However, the founding of the Yokohama Triennale in 2001 had given her cause for optimism. The port city had been the first location in Japan to open to foreign trade and cultural exchange in 1859, after two centuries of self-imposed national seclusion, and 'clearly it still leads the way in that respect', she noted. Kusama played a starring role in the Triennale, contributing both indoor and outdoor installations to the first edition: a mirror room in the Pacifico Yokohama Exhibition Hall, offering visitors 'an immersion experience in Repetitive Vision'; and *Narcissus Sea*, an installation featuring 2,000 mirror balls floating on the surface of the canal.

There would be many more biennales and triennales across the coming decades, and many more large touring exhibits. Between them, they would leave almost no corner of the globe unvisited as shows crisscrossed the world. A Tate Modern retrospective would travel to the Reina Sofía in Madrid, the Pompidou Centre in Paris and the Whitney in New York in 2012. A first Scandinavian retrospective, *Yayoi Kusama: In Infinity*, would travel from Denmark's

Louisiana Museum of Modern Art to Oslo, Stockholm and Helsinki in 2015–16, while the following year the first major Southeast Asian survey of her work opened in Singapore before travelling on to Brisbane in Australia.

So here was the Kusama paradox. The more she took her distance from the art world – 'I have no connection to [it] now,' Kusama wrote in 2002, '...I just dig ever deeper into myself' – the more the art world drew close to her.

* * * * *

Kusama, the 'magnificent outsider', as Akira Tatehata hailed her, was becoming a treasured insider, willy-nilly. She had always distanced herself from movements. As Tatehata had proposed: 'You haven't thought much about "isms", have you?' To which Kusama had responded: 'Nil.' Rather, as she said, 'All I did was do what I liked.' And increasingly, other people were discovering that they liked what this 'heretic' did.

As the art world globalized and turned increasingly to spectacular, immersive presentations, Kusama's signature pieces and trademark motifs – polka dots, mirror rooms, pumpkins – would grow in scale and proliferate in the landscape. The pumpkin, with its warmly, uncannily anthropomorphic appearance, had been a favourite form for Kusama in the drawings and paintings she made in her youth, and in September 1994 her sculpture *Pumpkin* was the first outdoor work to be unveiled on Naoshima, an island in the Seto Inland Sea then being transformed into an art site by the Benesse Corporation. The giant yellow and

black polka-dotted sculpture quickly established itself as a much-loved symbol of the new 'art island'.

Kusama had recently resumed making room-sized installations. There were the *Dots Obsession* works, in which a dot-spotted room is filled with vast biomorphic vinyl balloons, and then also *I'm Here, but Nothing* (2000), a dimly lit domestic interior in which the furnishings – dinner table, rugs, armchairs – are stickered with fluorescent polka dots that glow with unsettling, hallucinatory vividness in the gloom. The theme was revisited for children in the form of *The Obliteration Room* at the 2002 Asia Pacific Triennial (APT) of Contemporary Art at the Queensland Art Gallery. This featured a bourgeois interior like that in *I'm Here, but Nothing*, but here the young visitors were issued with brightly coloured dot stickers to place on the all-white surfaces and furniture. Self-obliteration for kids. And then Kusama made her first genuinely new *Infinity Mirror Room* since the 1960s: *Fireflies on the Water* (2002), a mirrored room containing 150 tiny coloured lights hanging over a pool of water, creating endless reflections. Visitors were intended to experience this hallucinatory vision of an infinite reality one by one.

* * * * *

The Tate touring exhibition was sponsored by the couture house Louis Vuitton, and was accompanied by a fashion collection, which included polka-dotted trenchcoats, sandals and bangles, and a pumpkin minaudière. The plan for Louis Vuitton to support the show had been hatched several years before, in 2006, when its then creative director, Marc Jacobs,

went to visit Kusama in Tokyo to film a documentary about his own work. She already had excellent fashion credentials, of course. Kusama had had her own boutique on Sixth Avenue and 8th Street, as well as a dedicated corner for her designs in Bloomingdale's in New York in the 1960s. More recently she had applied her skills to a range of items including cellphone cases as well as collaborating with the Japanese couturier Issey Miyake in 2000 and the French cosmetics and perfume house Lancôme in 2011.

LOUIS VUITTON × YAYOI KUSAMA was launched in New York in July 2012 during the exhibition's run at the Whitney Museum. For the London residency, a million dot-covered Tube map covers had been distributed to promote the show. Now the façade of the Vuitton flagship store was covered in a pattern of giant black polka dots, while the store window installation featured red-and-white polka-dotted inflatable tentacles. The artist herself attended the launch, making an entrance in a polka-dotted wheelchair. As one newspaper reported: 'everyone within a five-block radius of 57th Street and Fifth Avenue in New York City was seeing nothing but spots.' The artist's vision was colonizing the streets of Manhattan. It was the realization of a dream she had first had in the mid-1960s: working across media – art, fashion and film – to cover the world with dots.

Alexandra Munroe, curator of the CICA show that had helped to relaunch the artist internationally at the end of the 1980s, noted: 'If you had told me in 1989, when Kusama was virtually unknown in the New York art world, no less internationally, that those same polka dots that she used to paint on random New York performing artists...

would be translated into the façade of the Louis Vuitton on Fifth Avenue and 57th Street I would not have believed it.' As she explained: 'Kusama's story resonates with young people around the world. She is the female abuse victim who never married and emerged victorious in spite of ongoing mental illness…Patriarchy, sexism, fascism, racism – she slew them all.'

* * * * *

Kusama had described herself as a 'person of the hour' when she started making the front pages of the US newspapers in the late 1960s. In 2016, *Time* magazine went 8,760 times further (24 × 365) and declared her a 'person of the year', naming her as one of the 100 most influential individuals in the world. She was the only visual artist to make the cut.

She must have been getting used to such honours by this time. She had railed against an art establishment that in the 1960s had rewarded white male artists (Oldenburg, Samaras, Warhol) with fame for, as she alleged, appropriating ideas first developed by her. But by 2014, as a survey conducted by the *Art Newspaper* established, there was – officially – no more popular artist on the planet than Yayoi Kusama. Huge crowds gathered to see her work wherever it was shown. 'The vocabulary is very universal,' said Glenn Scott-Wright, a director at Victoria Miro, one of Kusama's galleries. 'It can speak to everyone.' More than two million visitors attended the touring show *Infinite Obsession*, which featured early work as well as her most recent painting series, *My Eternal Soul*, as it passed through Argentina, Brazil, Mexico and

Chile. 'South America Goes Dotty for Kusama,' proclaimed a story on Artnet. The Museo Tamayo in Mexico City had to stay open continuously for 36 hours to meet visitor demand.

Kusama's extraordinary appeal was not confined to gallery-goers, but extended to well-heeled collectors too. In 2014, she claimed the record for the most expensive artwork sold at auction by a living female artist when an early Infinity Net painting, *White Net No. 28* (1960), brought in $7.1 million.

In the same year as the *Time* magazine listing, Kusama received the Japanese Order of Culture from the emperor, becoming the first woman to be honoured by her country in this way. If Kusama had been vilified by some in her home nation during her years in the US, she was now becoming a national treasure. If she had once been erased from the membership list of the Matsumoto First Girls' High School Alumnae Association and declared the 'shame of Matsumoto City', the Matsumoto City Museum of Art was now proud to boast a permanent display of its most famous artistic scion's work. Kusama's giant, polka-dotted tulip sculptures had been guarding the museum's entrance since a major exhibition there in 2002.

Colleagues and interviewers have described recent encounters with Kusama. 'When you visit her, it's almost like a piece of theatre,' said Scott-Wright. Resplendent in her trademark wig, the artist might sit in a dress of her own design in front of a painting decorated with a similar pattern, still intent on merging with her work in an act of aesthetic self-obliteration. One interviewer compared her to a 'semiretired C.E.O.': 'Her staff coordinates exhibitions at her various galleries…and

executes new sculptures and dot paintings under her direc-
tion.' Her assistants address her respectfully as *sensei* (meaning
'master' or 'teacher') and translate questions posed in English,
a language she no longer attempts to speak. Another, noting
that she was known to have 'fired her longtime secretary three
times and, for good measure, once impulsively dismissed
her primary art dealer', declared she was 'the Red Queen
come to life'.

But for all this success, there remains some insecurity.
Frances Morris, curator of her globetrotting Tate retro-
spective, reported that Kusama had asked her whether
the show would make her as well known as Donald Judd –
a comparatively modest ambition for an artist when one of
her early Infinity Net paintings had recently sold at auction
for a little over $5 million. Another interviewer mentioned
being shown press clippings about the Tate show, with
Kusama particularly keen that she should see one taken
from a provincial Matsumoto City publication. 'There's
something touching about this need to prove herself, but
it's also confusing,' noted the journalist. A June 2012 piece
for *W Magazine* reported that she used to call her Japanese
dealer, Ota, 'five or six times a day'. 'Sales are important to
Kusama not because she needs the money but as proof that
the public appreciates her,' the writer concluded.

Kusama was also thinking about her legacy. She had been
a voluntary resident of the hospital in the Shinjuku district of
Tokyo since 1977. In 2017, Shinjuku became home to the Yayoi
Kusama Museum, occupying a brand-new earthquake-proof
five-floor building designed by Kume Sekkei architects. (Kusama
was so frightened during the 2011 earthquake that she ran into

the 2011 earthquake that she ran into the street in her bare feet. She was adamant that her new museum should not be heir to such shocks.) Kusama's studio is situated just across the road, so the new museum offers visitors something approaching an 'at home' with the artist. 'Kusama's work has been exhibited in many of the major museums, Biennales and Triennales all over the world. However, we believe that a private museum, whose concept originated with the artist herself, is an important, unprecedented opportunity for a deeper understanding of her unique trajectory,' explained its director, Akira Tatehata, commissioner of the Japanese Pavilion in 1993 and who played such a crucial role in re-establishing Kusama's reputation after her return to Japan. 'A dedicated museum will give visitors a chance to learn about the courageous battles that Kusama has fought as an avant-garde artist, allowing them to experience and feel the sincerity of her ideas, namely of saving the world through love.' The museum charted at number one on *Time Out*'s global Do List.

* * * * *

In the 21st century, social media provides a fresh route to fame, and perhaps even infinity. Yayoi Kusama became a huge hit on Instagram without even having an account of her own.

'Blame it on Katy Perry. Or maybe Adele,' opined the *LA Times* in October 2017 as the touring exhibition *Yayoi Kusama: Infinity Mirrors* prepared to descend on The Broad museum. Admission to the Downtown LA gallery was normally free, but a $20 entry fee was imposed for the show. Not that that dampened the public appetite. All 50,000 advance

tickets sold out in under an hour. A further 40,000 were released, and sold out almost as quickly. The Beatles hardly did brisker business when they announced their Shea Stadium show – in the circumstances, the growing use of the term 'Kusamamania' seemed fully justified. The previous year, the megastar singer-songwriter Adele, creator of *25*, the bestselling album of 2015, and followed by 37.1 million on Instagram, had recorded a performance for the BRIT music awards while standing in Kusama's *Infinity Mirrored Room – The Souls of Millions of Light Years Away*. She had got the idea, she said, after seeing an image on the Instagram account of fellow pop star Katy Perry (96.1 million followers). Hashtag Art Hit. Hashtag Ultimate Selfie.

'I definitely feel like standing in that room for an hour,' Adele said. In truth, such is the crush to spend a moment alone in one of Kusama's mirror rooms, which tap into the contemporary appetite for immersive, out-of-body, highly sensory experiences, visitors generally only get to stand in them for around 45 seconds; the time it takes to snap a selfie. Some years before, in 2013, when her exhibition *I Who Have Arrived in Heaven* brought an Infinity Room to the David Zwirner Gallery in New York, it generated six-hour queues of people desperate to get 'the season's hottest high-culture selfie', as the *New York Times* put it in a piece entitled 'Lights, Mirrors, Instagram! "#ArtSensation"': 'One click and there you are, floating in the universe, or rather, multiple yous, replicated over and over.'

The experience of standing in one of the artist's mirror rooms has been likened to an alien encounter, but it also evokes what Kusama had first experienced as a child when

her behaviour and passions proved so unfathomable to her mother. 'Kusama's Infinity Mirror Rooms exist to enact what she calls "self-obliteration", where the rooms' sense of infinite duplication makes us feel engulfed by our surroundings,' noted Clarisse Loughrey in the *Independent* in 2018, as a new Kusama show opened at Victoria Miro in London and Lenz's documentary hit the screens. 'And, when we photograph ourselves in one of her rooms, then post the image online, we are publicly erasing ourselves. It doesn't matter if you're Katy Perry: in the Infinity Mirror Room, you are merely stardust. A speck in the universe.'

Millions wanting to share the experience Yayoi Kusama had had as a child when a tablecloth pattern had begun to colonize the universe and she had feared being overwhelmed by infinite space. A world queuing eagerly to put themselves in the picture and self-obliterate.

The ultimate victory of Yayoi Kusama.

Selected Further Reading and Viewing

Books by Yayoi Kusama

Hustlers Grotto: Three Novellas, trans. Ralph McCarthy (Wandering Mind Books, 1998; first published in Japanese in 1983)

Infinity Net: The Autobiography of Yayoi Kusama, trans. Ralph McCarthy (Tate Publishing, 2011; first published in Japanese in 2002)

Manhattan Suicide Addict, trans. Isabelle Charrier (Les Presses du Réel, 2005; first published in Japanese in 1978)

Films

Kusama's Self-Obliteration (1968, art dir. Jud Yalkut)

Kusama – Infinity (2018, dir. Heather Lenz)

Articles and Books about Yayoi Kusama

Frick, Thomas, ed., *Love Forever: Yayoi Kusama, 1958–1968* (Los Angeles County Museum of Art, 1998)

Hoptman, Laura, Akira Tatehata and Udo Kultermann, *Yayoi Kusama* (Phaidon Press, 2000)

Yayoi Kusama (Victoria Miro, London, 2008)

In Full Bloom: Yayoi Kusama, Years in Japan (Museum of Contemporary Art, Tokyo, 1999)

Karia, Bhupendra, ed., *Yayoi Kusama: A Retrospective* (Center for International Contemporary Arts, New York, 1989)

Lippard, Lucy R., et al., *Pop Art* (Thames & Hudson, 1966)

Morris, Frances, ed., *Yayoi Kusama* (Tate Publishing, 2012)

Nakajima, Izumi, 'Yayoi Kusama between Abstraction and Pathology', in Griselda Pollock, ed., *Psychoanalysis and the Image* (Blackwell Publishing, 2006), pp. 127–60

Nixon, Mignon, 'Anatomic Explosion on Wall Street', *October* 142 (Fall 2012), pp. 3–25

Storer, Russell, ed., *Yayoi Kusama: Life Is the Heart of a Rainbow* (National Gallery Singapore, 2017)

Yamamura, Midori, *Yayoi Kusama: Inventing the Singular* (MIT Press, 2015)

Yayoi Kusama (45th Venice Biennale, 1993)

Yayoi Kusama Now (Robert Miller Gallery, New York, 1998)

Yayoi Kusama (Serpentine Gallery, London, 2000)

Yoshimoto, Midori, *Into Performance: Japanese Women Artists in New York* (Rutgers University Press, 2005)

—, 'Kusama Saves the World through Self-Obliteration', in *Yayoi Kusama*, exh. cat. (Pompidou Centre, Paris, 2011)

Index

Index

Index

Index

Index

Acknowledgements

I would like to express my gratitude to Muriel Zagha for her assistance with the manuscript. I would also like to thank the team at Laurence King Publishing for their support and expertise: Donald Dinwiddie, Katherine Pitt, Peter Kent, Marc Valli, Florian Michelet and Nicola Hodgson.

Picture Credits
(numbered in order of appearance)

1. Photo by MIXA/Getty Images
2. Photo12/Universal Images Group via Getty Images
3. Tony Vaccaro/Hulton Archive/Getty Images
4. Sueddeutsche Zeitung Photo/Alamy
5. Photo and copyright by André Magnin/Ad Peetersen (Montage), original only in the 0-Archive
6. Photo by David Gahr/Getty Images
7. Photo by Herve GLOAGUEN/Gamma-Rapho via Getty Images
8. New York Daily News/Getty Images
9. Courtesy and © Daily News Archive/Tribune Publishing
10. Photo by Chris Felver/Getty Images
11. Greg Wood/AFP via Getty Images
12. Alain Nogues/Sygma via Getty Images
13. The Asahi Shimbun via Getty Images
14. Matthew Chattle/Alamy
15. Itsuo Inouye/AP/Shutterstock
16. The Asahi Shimbun via Getty Images